The Misadventures of *Wunderwear Woman* in America

Denis Hayes

PARTRIDGE

A Penguin Random House Company

To order additional copies of this book, contact
Toll Free 800 101 2657 (Singapore)
Toll Free 1 800 81 7340 (Malaysia)
orders.singapore@partridgepublishing.com

www.partridgepublishing.com/singapore

Author and Illustrator
Denis Hayes

Cover Designer—Danish Aikal Hayes

Metamorphosis

Isabel had nearly forgotten her life as Wunderwear Woman. She was still quite a big girl but not nearly so keen on VPS, VBS and Camel Toe. She had toned down her confrontational style and settled into married life.

She was happy. Lance, her husband, was a great guy and they looked forward to every new day together.

They looked forward to every new day together.

Wonderful.

She was normal. She was nice. She was as sweet as Blueberry Pie.

The USA was an incredible country offering every flavour imaginable but once you were stuck in a rut you couldn't taste any of it. She was bored.

Normal American life for middle class women resembled Stepford wives. Isabel chuckled to herself, "Wunderwear would have called them Stepback Wives because they nearly always did. They conformed and acted their part perfectly. In a group you couldn't tell one from another. Full of insincere sincerity!

Whoops, that's more like it," she thought, "that's my Wunderwear Woman. Go girl go, just as you used to."

Lance wasn't the problem. It was everyone else! The Americans were fed on the propaganda that if everyone worked and studied hard then everybody could be the boss and be rich. 300 million bosses. Oh yeah!

So many of their friends talked that way that it was obvious it was just superficial chit chat without any real thought behind it. Wunderwear decided that this should be her first target as it was closest to home. Lance had no idea what was coming and neither did Wunderwear actually

Middle class American women—Stepford Wives—more like Stepback wives.

2

This was the USA where change and the free play of ideas was discouraged. It wasn't considered patriotic. Conformity, comfort and political correctness was the rule unlike Europe where only hypocritical lip service prevailed and the whole continent heaved with dissatisfaction.

Although the country was just begging to be ridiculed Wunderwear thought she could be in for a rough ride. She didn't care. She had never cared.

She had said it how it was in the past and she was going to do it again.

Her first opportunity came sooner than expected.

There's no such thing as Evolution!

Lance came bounding in one evening, "hey honey, fancy a Down South Camp Meeting?" he said with a grin on his face.

"What's that?" asked Isabel.

"Well it isn't really anything like what it used to be, but it still has a fiery touring protestant preacher warning of hell fire and damnation to all non-believers in a big tent. Singing, clapping, praying, healing, the lot. What d'ya say?"

"Wait a minute, what would mom say? She's Catholic and so are you and the rest of the family. Are you sure about this?" asked Isabel.

"Yup, it's fun. This guy doesn't believe in evolution. Says the Bible has the only true version. Everything else is wrong."

"Do what!? Is he out of his tiny mind?" shouted Isabel.

"Of course he is, he's religious ain't he? He ain't got a mind of his own. It's all decided for him" laughed Lance.

Isabel couldn't wait. She felt the return of Wunderwear Woman to be imminent.

Soon after leaving the city they joined a queue of slow moving cars. Virtually everyone had a family inside. No single drivers.

The land was perfectly flat, the horizon only broken up by clusters of trees.

They moved out of the Everglades onto higher firmer ground and caught glimpses of a large marquee set out in the open in the middle of a huge field.

Close to the marquee were other smaller tents amongst a group of huge trucks and trailers.

The fields around were steadily filling up with cars organised by marshals who were wearing dark suits and white stetson hats.

When it came to Lance he was ushered in to a relevant space between two pickup trucks. As the family stepped out to join the crowd heading towards the main tent they were greeted with "Hallelujahs", "God bless ya's" and "Praise The Lord" from every direction.

Everybody seem ecstatically happy, even a little hysterical.

"What's with these people?" exclaimed Isabel, "what are they on for goodness sake?"

"Oh boy, if you think they're high now you just wait till later," laughed Lance.

"Have we really got to do this?" she asked.

"Yep, you'll love it. Mom does. She manages to contain herself until they insult the Pope and then she's on her feet screaming blue murder."

"Right, I can't wait," said Isabel with a smile.

They filed in and took their seats about halfway down facing a central stage.

The stage was surrounded by flowers with two sets of wide short steps leading up from the front and two smaller sets running from behind curtains on either side. The stage was equipped with mikes, amplifiers, seats, drum kit and music stands.

Before the stage, right in the centre was a marble font.

The font was standing on a plain white plastic sheet.

The marquee filled up rapidly.

The crowd was relatively subdued although there was a continual expectant buzz around the whole time.

Suddenly a short, tubby, bearded guy with more fuzz around his face than on his head, dressed in a light brown suit covered by a blue university gown leaped onto the stage from one of the side wings. He enthusiastically shouted, "Hallelujah, Jesus saves, Jesus loves you. Welcome to the love of Jesus. Thank The Lord," and raised his arms up in the air in supplication.

Those in the first few rows responded.

Not quite getting the wholesale reception he expected he looked around a little confused until a slim young girl, ran out bending low, trying unsuccessfully to keep a low profile and handed him a mike. She crept out shuffling backwards with an embarrassed smile on her face waving her arms expressively and futilely in the air.

He smiled, tapped the mike with no result, tried again, failed again and looked helplessly off stage.

"Turn the fucking thing on man," bellowed a huge male voice from the crowd, followed by a moments embarrassed silence.

"Jesus saves sinners," came a shrill woman's voice, "please save this ignorant foul mouthed husband of mine oh Lord."

"Just shuddup for Christ's sake and get on with it," screamed the husband, "Oh sorry folks. Hallelujah, praise The Lord."

He sat down getting withering looks from his wife but re-assuring pats on the back from his male neighbours. He looked around grinning awkwardly.

Mr. Tubby regained his composure and started again.

"Please remember that this is the Lord's house because he said that wheresoever thou art gathered together in my name there I am also.

You are in the presence of the Lord tonight my brothers and sisters. He is here to welcome sinners who repent. Are there those here who are sinners?"

"Yes," came the mournful response.

"Have you come to repent?" cried Mr. Tubby.

"Yes, oh yes," went up the cry.

"Then Jesus loves you. Jesus welcomes you. Jesus will save you and The Lord will protect you for the rest of your life."

A great blissful sigh went up from the crowd.

Tubby had them and was swift to follow it up. He was joined on stage by a choir of elderly blue rinse ladies dressed in white flowing robes with fixed synthetic angelic smiles on their faces.

"Just look at those smiles," Lance remarked, "They're set in cement for heaven's sake. Totally forced."

"Give 'em a break," smiled Mom, "they have to do this every night. Their husbands died years ago, killed off paying the mortgage and the kid's education. All they've only got left is a reasonable pension, not enough to trap a man on a Carnival Cruise, so they turn to Jesus.

Actually their mouths turn down along with the wrinkles but botox and makeup work more miracles than the good Lord."

"Quiet you two," Isabel said, in an attempted whisper, "let's go with the flow?"

Tubby stepped down to the font.

"Who will be the first, who will come to Jesus to be cleansed of sin? Who is there who will face the people gathered here tonight and say, I have sinned mightily, I repent oh Lord, take me in your arms and forgive me, a poor sinner!"

A murmur ran through the marquee, one or two seemed about to move but settled again. No one went up.

Tubby's voice thundered out ominously, "who here is going to say get behind me Satan, I reject you and all your evil ways. Who will reject the Devil and all his works and embrace The Lord your God? Can you sit there in the presence of the Almighty and say you haven't sinned?"

He peered around threateningly.

There were definite ripples spreading this time but still no rush to the font.

Tubby started to have a slight look of desperation on his face and in his body language. He glanced towards the wings and then urged the ladies on stage forwards. Organ music started up from somewhere behind the curtains and the onstage angels started to sweetly sing "What a friend we have in Jesus."

"Come on brothers and sisters, you are here today to meet before your Lord God. Who here has not sinned?" crooned Tubby over the music, "who here can can truly cast the first stone? Who wants to remain in purgatory for ever, roasting in hell, screaming in agony for eternity, when you can come to beg forgiveness now before it is too late?"

This time there was movement.

Tubby acted quickly, he took hold of a waverer on the end of the second row, pulled him to his feet and shepherded him to the font surrounded by the singing elderly cherubs.

The music and singing continued with Tubby yelling his head off over the top of it all, "do you confess, do you reject the devil and all his works, do you beg for your sins to be forgiven? Oh hear this sinner oh Lord, hear this poor, poor sinner."

"Oh hear this sinner oh Lord, hear this poor, poor sinner," cried Tubby.

As the man fell to his knees weeping Tubby splashed water over his head and exclaimed, "with this holy water I proclaim you a child of God with all sins forgiven. Do you confess and embrace gentle Jesus?"

"Yes, oh yes, forgive me Lord, I was a sinner but now am saved," cried the man, putting his hands together and moving his lips in prayer.

The voices and music became louder as they helped the man back unsteadily to his seat. The guy looked more bewildered than saved but that had opened it all up. The crowd was shouting "amen, hallelujah and praise The Lord." Men and women flocked towards Tubby.

Marshals appeared, no longer organising traffic but organising the repentant sinners into an orderly queue.

Tubby was radiant.

All went well for a time but then a number of women, perhaps becoming impatient, started to wail, twist and turn, maybe looking for their fifteen minutes of fame. They were obviously competing.

One upped the ante and screamed, "save me, help me, the devil has me in his clutches," and began to tear her hair.

Seeing the attention this got another decided to go one better.

"The devil's taking me, he has me in his arms, Jesus rescue me," she cried, and started to rip her clothes off.

No one moved at first. Everyone waited with bated breath to see what would emerge. By the time she had got down to bra and pants the crowd had seen enough. It was not a pretty sight.

"Let the devil have her," came one shout, "it's horrible."

"Please God help her," exclaimed another, "help her to put her clothes back on right now!"

"Someone buy her a washing machine and shower," called another, "that's not tasty."

"She sags more in the middle than my hammock, we should all pray hard for her," cried a really old guy.

The singing angels rushed to the rescue covering her up and the marshals carried her out.

The queue moved up and on.

The music changed to 'Take me to the River,' and 'Just a Closer walk with Thee.'

The crowd applauded each repentant sinner and the lights changed hues to give a more heavenly feel.

The crowd were on their feet, swaying to the music and clapping their hands more or less in time. Many were looking at each other with radiant looks on their faces urging each other on in celebration.

The queue of repentants showed no sigh of diminishing but the reverend Tubby showed distinct signs of fatigue. He was sweating and puffing and signalling frantically at the curtains between sinners.

Someone eventually got the message. The organ reached a crescendo and then rolled into a finale with the choir of angels lifting up their hands and voices bringing everything to a glorious conclusion.

The crowd subsided and the queue of sinners looked bewildered and abandoned.

Tubby took up the mike. He cried dramatically, "brothers and sisters heaven is full of repentant sinners for tonight, come back tomorrow at the same time and God will forgive you."

The marshals ushered the remaining unforgiven sinners back to their seats as Tubby speedily carried on. He needed too because the unfulfilled were definitely put out at being put off. Neither they nor the marshals were behaving in a gentle forgiving way. Helpful arms were shoved aside

and elbows stuck out digging into soft spots and there were more than a few dozen petulant resentful expressions flying around.

The atmosphere deteriorated. Tubby had to get a grip and he did.

"However folks, Heaven may be full of saved sinners but it's coffers are empty. Our heavenly angels will pass amongst you all with flour bags that have been blessed and we ask you to give generously so that we can continue with God's work. Remember the words of gentle Jesus, "it is easier for a camel to go through the eye of a needle than it is for a rich man to enter heaven. Amen and God bless you all."

He and the choir slowly retired spreading sweet smiles and gestures around to everyone as they went.

The music and the collection carried on.

"Great isn't it?" shouted Lance happily, "better than watching a Rambo film."

"Yeah," laughed Isabel, "and just about as real. What a con. Why do they fall for it? All the people here look normal but are behaving like lunatics. They're just being fleeced. In the religious terms of the tubby reverend—like lambs to the slaughter."

"Yep, and they love it. It's a great family night out and for a few bucks they can feel pure and good about themselves and have a community sing song to boot."

"I get that but still find it a bit creepy though," said Isabel, "I can understand the good night out bit as long as they don't believe all the crap. God makes his judgement when you die not reverend Tubby while you live. Tell God, not Tubby. I wouldn't buy a second hand car from him, would you? Certainly not forgiveness."

"I like the way that the fainting, frail followers who fall into his arms revive so quickly," said Lance.

"Probably got bad breath," said Isabel, "brings you back to reality real fast."

"Whisky more like," said Lance, "hello what's happening now?" and he pointed towards the stage.

A small combo occupied the chairs and took up their instruments led by a guitar player wearing a ridiculously tall domed stetson and an inane grin.

He reminded Isabel of Hopalong Cassidy.

The choir followed and immediately they all swung into an up tempo version of Give Me That Old Time Religion.

The crowd rose up, swayed and clapped hands.

As the spiritual came to a close a slim earnest looking preacher walked slowly and thoughtfully onto centre stage.

He looked down for some time allowing the crowd to settle and the mood to change.

Then he looked up and up and up.

It was a miracle that he didn't fall over backwards but of course this guy was a believer so he was used to miracles.

"Almighty God," he mouthed tonelessly," forgive us our sins and deliver us from evil. Bless everyone here tonight. Hallowed be thy name, Amen."

The crowd mimicked the Amen and waited expectantly.

Suddenly he roared out loud, "why are you here tonight? Why have you come from your homes, and farms and businesses? Have you come to hear the word of The Lord? Have you come to believe and be saved?"

"Yes," roared the crowd, "yes we have come. Hallelujah, praise The Lord." There were individual shrieks and cries all around the tent.

"Then look to God. He is our lighthouse when on stormy seas, a beacon guiding us to safety," he cried, "he will bring us safely through all life's temptations."

"There are so many ways to fall by the wayside, good people, don't listen to the sinners. Keep to the path."

The background music grew louder, and his voice grew more strident, "there are those who do not believe in the word of God as told in the Bible. Can you believe that? There are those who would tell you that it is not true.

Can you believe that? There are those who say we are not made in God's image. Can you believe that?"

By now the crowd were on their feet shouting and screaming a mixture of acceptance and denials as he had got them truly mixed up and worked up.

Now he had them where he wanted.

"There are those who deny the great book of Genesis and who believe in evolution. Can you believe that?" He slowly repeated with great emphasis, "can you believe that?" He paused, dramatically, "what do you believe?

As the crowd shouted at him a variety of responses he turned to the band and choir who picked up on a plinky plonky little tune which ran

along the lines of, 'if they say they believe in evolution ask them if they were there'.

At the end he thanked the group and turned back to the crowd.

"Scientists," he bellowed, "believe they know the answers to all the questions. They deny the work of God. They find old bones buried in the ground and are amazed. Why? Where did they expect to find them? Anyway where are these monsters and their bones? I've never seen them. They scrutinize rocks and say they are old. We know they are old. God made them old when he made the earth. Of course they were there before us. Don't they read the book of Genesis?"

He was really working the crowd. Many were on their feet, shuffling, twisting and singing while cries of 'Hallelujah' and 'Praise The Lord' were being hollered from all over.

"Science gives answers to nothing at all but The Bible tells us everything. Scientists say this and say that but where do you see the results of science. I only see the work of God. They say they have evidence of the beginning. I say 'were you there?' If anyone tells you about evolution just ask them 'were you there?'

I believe God's word in the Bible which starts with 'in the beginning' because he was there!! Amen."

He shrunk back apparently exhausted and gratefully accepted the helpful arms of his assistants and the fervent applause of the crowd.

"If they tell you about evolution ask them if they were there."

Almost immediately a strident voice boomed out from the crowd, "but you weren't there either were you? You blab on and on about the beginning but were YOU there? No you weren't and neither was anyone else." Isabel had been transformed into Wunderwear Woman and she was on her feet, "science has proof and evidence but you only have faith. Highly commendable but it doesn't make you qualified to ridicule the work of brilliant people who have offered so much to the world using that beautiful gift from God called the brain. You obviously don't use yours much, you prefer to use your mouth.

You ridicule science yet you use electric lights, generators, mikes, amplifiers, huge trucks, airplanes, refrigerators and goodness knows what else. None of them figured in Genesis did they?"

Wunderwear was warming up while Lance kept an eye out for the marshals.

There were ominous murmurings from the crowd who had mainly been stunned into silence at first.

The people on the stage seemed shell shocked.

"We know we find old things in the ground. It is not so much what they are that matters but how old they are. Are you disputing carbon dating? Do you really dispute that scientists have joined remains into species that roamed the earth millions of years before the time of humans? Go to the museum. They have thousands of species in fossil form that you can see. Some are complete others are not. But they are there. Oh yes they are there but you're not."

Lance pulled at her arm, "time to go babe, you're getting them more worked up than the preacher. Except they liked him!"

"I know but I've got to tell them he's not even an American." Wunderwear yelled, "That so called preacher, he's not American, he's Australian, check his green card if he's got one. He's probably here spouting all that rubbish because the down to earth Aussies wouldn't give him the time of day."

The last was delivered over her shoulder as Lance and the family dragged her away.

The preacher recovered himself, signalled for music and said sweetly as if nothing had happened, "the work to promote The Lord is unceasing. We will now pass around the bags for a donation, please give generously once more," and he left the stage sweating profusely and complaining like mad with his acolytes trying hard to pacify him.

Outside the marshals converged on them but halted when they saw that they were on their way to the car park.

Mom glanced sideways at her daughter in law. Wunderwear was submerged for the time being, Isabel was back. "Mah oh mah, you are a feisty lady ain't ya," smiled Mom. "Just as well you got in first because he sure was goin' ta insult the Pope somewhere along the line. When they get worked up they don't know when to stop. Helps them to pass the money sack around more often."

"Ah tell you girl if he had gone on much longer then I wouldn't have beaten him up verbally lak you did. I'd have punched his lights out. Was he really Australian? How did ya know?"

"It was his accent Mom. He had an Australian accent," replied Isabel.

"Australians have an accent? Well, well, who would have thought it. They look just like us don't they? Just shows you never can tell. Glad I ain't got one though. Come to think of it you talk a bit funny Isabel don't ya?" Mom asked with screwed up eyes.

"Yes she does," laughed Lance, "but she tries hard to speak English like us doesn't she?"

"Well ah guess she does but she needs to try harder. Anyway enough of all that, get me to a bar right now. I need a few drinks."

"A bar Mom. After all that religion. Is that being a good Catholic. What would the Pope say I wonder?" Lance said attempting to be serious.

"Don't get fly with me my son," Mom laughed, "I said the Pope could do no wrong. Didn't say it applied to us ordinary folks did ah? Now get us to that bar. No fancy pinkie finger drinks mind, a gallon tub of beer will do nicely."

They piled in the pickup and shot away with the tires burning a fair bit of rubber.

But YOU weren't there in Genesis either were you?" she cried.

15

Those Darned Immigrants

They settled themselves down a decent distance from the bar comfortably at a low, long table.

They looked around with satisfied grins on their faces. A respectable place but no too snobby. Just right.

"Hi, what can I do for you folks tonight?" said a bright young redheaded waitress, "are you ready to order?"

"Yep," said Lance, "Buds all round if that's okay with everyone."

There was a chorus of ayes.

The waitress shishayed away watched by dozens of eyes all over the bar.

"At least he didn't come out with the 'Fishers of Men' stuff," muttered Brad, Lance's older brother.

"Who you talkin' about for christ's sake?" exclaimed Jeanette, Lance's younger sister, "what are you on about now?"

"The Preacher, that's who. What duya think I was on about?"

"I dunno, once you go off then no one knows where you gone," she laughed.

"Don't worry Bro' I'm with you," Lance said encouragingly, "what a dickhead he was. He sneered at the very science he used everyday. If science had got it so wrong then he'd have blown himself up ages ago."

"Yeah, now that's a thought," said Isabel, "if electricity was cockeyed then he'd be lighting up the skies for years. That would impress the congregation.

Really bring his lighthouse sermon alive wouldn't it? It could be called Reality Pulpits. Preacher in the Sky with Diamonds."

"The point is the dumbos take the bits they like and reject the bits they don't like. If it's inconvenient they just deny it. The fact that it turns them into liars seems to make no difference to them. So much for religion eh?" said Mom.

"Never mind, let them believe what they want to believe. One of us is in for a shock when we die," chuckled Jeanette, "one way or another we'll all be part of eternity even if we don't know it."

"What I don't get is this belief that if you deny everything and live like a hermit it's supposed to take you closer to God and make you very wise," Lance said, "It seems like an excuse to cop out, be dumb but appear smart. They say the daftest things with great seriousness and people nod their heads as though impressed."

"Yeah, I remember Richard Gere on a tele talk show telling everyone of this so called remarkable question he was asked by the Dalai Lama," said Isabel, "He had asked Richard if he actually became the character he was portraying in the film. Richard then looked around expecting everyone to be stunned by the sagacity of the Dalai Lama but nobody was. Well maybe he was and his sycophants pretended to be but to everyone else it was just a normal straight forward question. That question had occurred to my brother and I when we were about ten years old. How embarrassing for the Dalai Lama."

"Good job he took up acting then wasn't it?" Mom sniggered.

"Who, the Dalai Lama?" exclaimed Brad, "thought he was a Chinese rebel or something."

"Whoops, he's gone again," laughed Jeanette

"What?"

"Never mind."

"Oh, okay."

There was silence for a while as the drinks arrived.

Over in the far corner a noise had been building up. A group were obviously celebrating. They weren't just drinking. They were pouring it down. Some had to be helped to their feet to enable them to top up an already overloaded bladder. There was a steady stream to the toilets which

was just as well as they would never have found it on their own. Those coming back helped to steady those going forward but it became more of a hit and miss affair as the evening wore on with misses outnumbering the hits. The hits looked amazed at the contact and the misses appeared bewildered at being somewhere they didn't want to be. Those who found themselves not being where they wanted to be were helped back to the group but of course they didn't want to be there either. So they started their journey all over again.

"How do they control it?" asked Brad in amazement, "I'd have pissed myself by now."

"You'd have pissed yourself before now," chuckled Jeanette.

Brad nodded and said, "yes, you're right," and carried on watching.

Mom peered through and asked, "Isabel, is that an English or Australian accent I can hear? Sounds foreign to me."

"No Mom, they're Russian. They're speaking Russian."

"OH MAH GAWD, have we been invaded, have we all gotta be commies now?" cried Mom.

"No Mom, calm down, they're probably foreign contractors or immigrants," said Jeanette helpfully.

"More like illegals. Should we report them," she whispered conspiratorially.

"No need, Mom, they're okay. Lots of us came to the States for a different way of life. Same as you and Pop," said Lance gently.

"Yes I know that but we weren't lapsed communists were we. We were just disillusioned socialists. Big difference. The immigrants today don't want to come for a new life they want to change ours. Not good. I mean those Mexicans keep coming and complaining, they want their territory back, but if we hadn't taken California they'd have had to hike it to Oregon to get in. That would've slowed them down.

Mark my words the immigrants will always cause trouble."

A Minneconjou Sioux Indian sitting in the corner smiled and said, "tell me about it!"

Having trouble with immigrants?—tell me about it!

"Tell me when we are going to get our land back. If you can't do that then stop complaining."

There was silence at first.

Then.

"Who's he?" asked a very puzzled Mom, "isn't he illegal?"

"No, he's down here for a Native Tribes Convention," said Jeanette, "he's in Sioux tribal dress. They spend their lives trying to get something out of a very bad deal."

"Well he won't get it looking like that though, will he?" Mom said firmly, "hasn't he got a suit or something. Brad you could lend him one of yours, he's about your size. He won't get a job attending interviews like that will he? I mean it's pretty and all but even gays would refuse to go out like that wouldn't they? Well, maybe not come to think about it. I know a few who might. My sister Vera's son for a start. Never know whether I'm talking to a niece or nephew. What's the world coming to?"

She paused, completely out of breath.

"Take it easy Mom, you're getting wound up. Drink up and let's get some more beers in," said Lance, "wait a minute, where's Brad?"

They looked around but couldn't see him.

A few minutes later he turned up a little wet.

"What's with you?" asked Isabel rather concerned.

"Fuckin' hell man," exclaimed Brad, "I wanted a piss but couldn't get anywhere near the bathroom for those Russkies. They're falling over each other and missing the bowl by miles."

"Oh no, is that how you got wet?" asked Isabel all concerned.

"Nah, don't be stoopid, I went outside to the car park didn't I?"

"Okay, but how did you get soaked all over? Missed the target again did you?" laughed Lance.

"No, don't be a wise guy," said Brad, "it's bucketing down with rain outside and I couldn't hold it in any longer. I just had to go whatever."

"See I told you those commies would cause trouble didn't I?" said Mom.

"Can it Mom, you're starting to sound like Sarah Palin and the Tea Party," said Lance, "That record's worn out by now. Next thing we know you'll be voting Republican."

"What, that's blasphemy, wash you're mouth out young man. I would sooner be struck by lightning than vote for those traitors. They wasted millions of dollars on pursuing that nice young fella, what's his name? Bill Clinton, that's it. All 'cos he couldn't resist the temptation offered by a bright young intern thing who got a bit carried away. She fancied a bit of the President for lunch one day. He'd have had to be gay to refuse. I can understand his wife making a fuss but not the politicians. Had to be jealousy, just like the nosy bitch who told the girl to spill the beans."

"Yeah typical," said Isabel, "those who have shit lives always want to ruin someone else's. Pathetic."

"Anyway Clinton didn't lie under oath. One blow job is hardly having a sexual relationship is it?" said Jeanette, "well not in my experience at least." She looked around happily until a threatening look from Mom quietened her down.

There was silence for a while as the women contemplated giving a blow job to a handsome President and the men thought about getting one from a gorgeous young intern.

Suddenly, "Reckon he was a pervert, that's what I think," this came from Brad.

"What!? Clinton a pervert? Is that what you're saying?" Isabel cried in horror.

"Nah, don't be stoopid," he said, "that there public persecutor fella. Weird the way he kept jerking himself off on the details. On and on. Couldn't get enough of it with each sentence costing the country a thousand dollars or more. Should be in jail the lot of 'em. Made the country a laughing stock and made a man out of the President. Them Republicans don't give a damn about the country. Rather waste the money than allocate it to a good cause. Political masturbation is what I call it."

"Wow," shrieked Jeanette, "that's a whole lot of big words and ideas for you to come out with. Anyway he was a Public Prosecutor not Persecutor."

"Liked my word better," said Brad.

"So do we," laughed Lance and Isabel together sounding as though their voices came from stereo headphones.

"Soon forgot me, didn't you?" said the Sioux from the corner, "typical. More interested in sex than settlement."

"What's with you?" exclaimed Mom, "what do you want for crissakes? Keep on interrupting our sparkling conversation like that."

"We want our land back," he said quietly.

"How long ago did you lose it?" asked Mom.

"About 150 years ago, if you're asking. Along with the buffalo."

"Jesus Christ, excuse me Lord, but you have millions of hysterical Arabs screaming their tiny minds off in rage at the Jews getting their country back after 2,000 years and you want yours back after just 150? Get real, man, get real," shouted Isabel.

"Where will we go?" asked Mom plaintively, "where will we go?"

"What are you going on about Mom?" asked Lance, "where do you want to go?"

"Nowhere, you moron, that's the point," Mom cried, all upset, "but he wants his country back. Millions of us will be milling around being a nuisance all over the world and his lot will be wandering around miles of empty space looking for captive buffalo to release so they can kill them."

"That's not what I mean," said the Sioux, "we were cheated out of land for a handful of beads and promises. We got the beads but not the promises. Our culture at the time did not understand ownership of land given by God. The land is here long after we are gone so we agreed

because we thought the white man was nuts. He wasn't. He was a greedy liar. So were we at times but not as often as the white man. We want to re-negotiate the deal."

If we got $50 billion worth of land for free why is the country in such financial trouble now? asked Jeanette.

"Okay, we get it. I think you have our sympathy," said Lance, "what's the deal?"

"We want a fair price for the land at the time plus the interest," came the swift reply.

"Seems reasonable. How much will that come to?" asked Brad.

"Would a quick estimate do you?"

"Yeah okay. Fire ahead."

"More than $ 50 billion."

Silence.

Then.

"Good luck fella, see ya around."

They finished their drinks and left.

As they reached the car and were ducking out of the rain Jeanette said wonderingly, "If we got $50 billion of land for free why is the country in such financial trouble now?"

"Easy," replied Mom, "it's the Republicans."

"Hee, hee, hee," chuckled Brad," that should have been Clinton's theme for the election shouldn't it?"

"How come?" asked Lance, "don't get it."

"Well when he was asked what the main issue was facing the USA at the time he said 'it's the economy, stupid.' He should have said, 'it's the Republicans stupid' and saved the country a lot of time and money."

"Gotcha," said Lance, "it should have been the same for every election."

They all nodded wisely.

One Language?

After a good hard day's work and a round of pizzas the family were settled down in front of the TV. They were watching Cajun Pawn Stars. Isabel soon began shaking her head.

"Lance, what language are they speaking?" she asked, I can hardly understand a word. Is it pidgin English or something?"

"No," said Lance, not really paying attention, "It's English."

"Listen to me," said Isabel, "pay attention. That's not English, believe you me."

Lance looked at her, "what's your problem? I can understand okay."

"My problem is that I can't. I can't tell the difference anyway between the men and the women. The men have all got such high pitched squeaky voices making noises going woau woau wang waang. They sound like illiterate Mickey Mouses. Look my dear husband, I am English and trust me, English that ain't! If you're going to steal my native language then at least try to speak it properly otherwise there's no hope for English in the USA."

"Don't get on your high horse. I'm not a hick," smiled Lance thinly, "I get you. It is put on a bit for the programme I hope and it's not attractive. Makes them seem a bit dumb. Anyway you do have some strong accents in the UK. You know that so don't be difficult"

"Yes I do know but we do try to make ourselves understood, not the other way round," she argued.

"Well a lot don't succeed so cut it out," snapped Lance, "there's that gorgeous English singer who we all fell in love with until she spoke. Hadn't a clue what she said."

"Yeah but she was gorgeous though," grinned Isabel, "can't say that about the Cajun lot can ya?"

"Nope but that's not the point. They're not supposed to be glamour pusses," said Lance, obviously still a bit irritated.

"Why are you so touchy about this," smiled Isabel, "I bet you are just being patriotic and defensive because I'm English and criticising your countrymen."

"You've got it right there honey," said Mom joining in for the first time, "I can understand you even with your funny cute accent but I can't understand this lot. Neither can Lance. He reckons it's like hearing someone scratching a stone down glass. Don't take any notice of him."

"Yeah," chimed in Brad, "we think they sound like fairies. Not like those Las Vegas Pawn Stars. Not exactly sex symbols are they but at least they're like real men and we can understand them."

"Yup, but not sure about one of them. You know. The one with the baseball cap ten sizes too small and a brain to match," laughed Jeanette, "good series though."

"Hey yes, you're right on that," agreed Isabel, "I could understand them, no problem. Can we switch channels? Cajun is just a second class copy."

They did.

They watched Kings of Restoration.

They were spellbound. "These guys are geniuses," said Lance, "I can fix anything to do with boats, these guys can fix anything."

"Awesome," agreed Jeanette.

"Bloody great," offered Isabel.

"Amen," said Mom.

"Wait a minute," exclaimed Jeanette, suddenly leaning forward in her chair.

"What, honey, what?" asked Mom looking puzzled.

"Did you hear what that little kid shouted out when he saw the finished job. He's about eight or nine years old and bawled out 'holy crap' at the top of his voice and his pop didn't say anything. Disgusting."

"Oh my god, if he's got a foul mouth like that at his age what's he gonna be sayin' when he's a teenager?" said Mom, "don't his parents care?"

"You know how it is Mom," said Isabel, "too many parents think their kids are wonderful little saints when the rest of the world sees them as spoilt brats. Happens all the time."

"Didn't happen with my lot," Mom grunted, "and it didn't happen with you did it?"

"Nope, we had to be very careful what we said and how we said it which is why I'm a rebel now," laughed Isabel, "I remember when I reached eighteen I went down the garden and made whole sentences up using only swear words. Great, got it out of my system. Never bothered afterwards."

"He's too young to know the difference between holy and crap that's the trouble, and as for holy crap well even the bishop's shit doesn't reach that level," Brad mused philosophically, "stands to reason."

Stunned silence.

"There you go then," said Mom, Counting Cars was next up.

The family were slowly sinking lower and lower, sagging more and more as the evening went on. Cans of Budweiser helped them on their way.

However the verdict on Counting Cars was similar to Kings of Restoration.

Geniuses. Except.

"Why do they walk around with their legs and arms spread out as though they've shit themselves and growl in gruff voices instead of speaking properly?" asked Isabel. "they are really clever. They don't need all the bullshit."

"American men think it makes them look tough and manly, sweetheart," chuckled Mom, "that Godfather film has a lot to answer for. You can't be a hard man here unless you partly whisper gruffly as though you have a sack of sand down your throat, hunch up with round shoulders and walk with your legs apart as though there's a hot iron shoved up your arse."

"To me bodybuilders walk as though their two legs are going in different directions to their body," grinned Jeanette.

Brad looked across at her, "you should see them stripped off. Nothing seems to fit anywhere let alone go in the same direction. They've worked

so hard on individual bits and pieces that nothing really goes together anymore. Gruesome!"

They all nodded wisely.

Why do they walk around with their legs spread
out as though they've shit themselves?

The Visit of the very Reverends

I t was a Saturday afternoon.

Lance's fishing fleet were at sea going to deep water and would be away for several days. His freezer shop and cannery were cleaned up and clear awaiting the fresh caught fish.

The family relaxed.

"We're going to have visitors," declared Mom, "important people so I don't want any funny business or wisecracks. Understand?"

"Wow, what goes on Mom?" exclaimed Brad, "what's different? It's you who's usually out of order. Why you picking on us now?"

"For your information it's the Right Reverend Father O'Halloran and Bishop Clancy," announced Mom proudly as though it was Royalty.

"Oh for goodness sakes Mom," cried Lance, "are you telling us we've got to put up with a couple of self-righteous Micks all evening?"

"Yes, and you will make sure your brother doesn't hide the whisky and brandy like last time or as old as you are I'll take the paddle to you," said Mom, "you laughed your head off but it wasn't funny."

"That's because they started singing Irish songs after a few glasses," said Lance.

"What's wrong with a bit of ' When Irish eyes are smiling' and 'Killarney'?" she asked, "Bing Crosby did it."

"They weren't singing those songs Mom. They were singing 'we're behind the boys behind the wire' and other rebel songs. One of them's a bishop for God's sake."

"Aye, and they're good Catholics too. Stout lads, all of 'em," said Mom.

"But not terrorism Mom. Catholics shouldn't support terror," argued Brad.

"They had a bloody good try years ago when they burnt people didn't they?" exclaimed Isabel, "said it was for the good of god just like the terrorists do now."

Fortunately Mom didn't hear but Lance did and shot her a warning glance.

Isabel felt Wunderwear arising inside her but squashed it for the time being.

She would save herself for the priests.

Mom peered out the window as they heard a car draw up outside. "That sneaky bastard O'Halloran has borrowed a beat up old Toyota for the day to drive the Bishop around. He's pleading poverty and trying for a raise. Clancy won't fall for that."

She let them in and ushered them into the living room.

"Sorry we're late Maria but O'Halloran insists on living meagerly with an unpredictable car," said the Bishop immediately, "I told him that it's very commendable. I wish there were more like him in the diocese. He must feel very uplifted."

"Looks more downhearted than uplifted," grinned Brad.

"Now then, shall we get straight down to it?" said the Bishop.

"Right your Grace. Will you lead the prayers or shall I?" asked the Right Reverend O'Halloran.

"Prayers? Good Lord O'Halloran. We're amongst the faithful here. I meant the whisky! Now then Brad, pour it out lad, don't hide it like last time or I'll excommunicate you. Ha ha ha."

"Of course," agreed O'Halloran, "we're glad to be here Maria among true Northern believers. You've no idea. Most of the people we visit come from south of here and have a job finding a decent wine to offer us. Not a Guinness in sight let alone a dram of the water of life."

While the reverend was talking the Bishop had downed his drink and was offering up his glass for another.

"Can the cackle Father," he said, "get down to business. I'm all about business you know."

He offered up his glass again.

"Maria," O'Halloran said ponderously, "Maria."

"Yes Father," said Mom

"Maria," O'Halloran started to say again.

"For god's sake Father get on with it. I know her bloody name. I've known her for years," the Bishop blurted out, "have you got any brandy Brad? If I remember rightly you had a decent cognac before."

Brad winced and went to the cabinet.

"Maria," said the Father, and went on quickly, "we have come to you today on a mission. A mission of mercy."

"Oh God, how much does he want this time?" exclaimed Jeanette, "is he after a new Toyota your Grace?"

"No, no, no. Not at all," said the Father hastily, "we want children."

"Oh my goodness," said Isabel, joining in for the first time, "aren't you supposed to be celibate? Anyway I'm married, Jeanette is spoken for, Mom is past it and if either of you touch Brad then we'll kill you."

"Dear oh dearie me," said the Bishop, "it seems the good Father can't hold his drink too well. Explain yourself properly man!"

O'Halloran looked at his empty glass in disbelief.

"We have come about your children," Clancy said, holding up his glass again, "Maria, you had five little ones, three of whom survived but you have no grandchildren. When will we see them appear to add innocent beauty to our flock?"

"They wouldn't seem so fuckin' innocent if me and Jeanette had any would they," snorted Brad, "they'd be illegitimate little bastards wouldn't they?"

Lance looked daggers at him and Mom took a few big swings at him which fortunately missed before Isabel rescued him and shoved him out the door.

"Nothing wrong in the old plumbing Lance, is there," asked the Bishop shyly.

"No, nothing wrong at all. Nothing wrong with my wife either. We go at it like rabbits. Can't get enough," boasted Lance.

"Then why no results?" asked O'Halloran aggressively, "good Catholics, with God's good grace, would have had two by now. You haven't sinned have you? You are not practising illegal birth control are you?"

"No, all is legal as far as we're concerned. What does legal mean in your book anyway?" asked Isabel.

"To talk bluntly it means not doing it at all or pulling out before you pop or just taking a chance and trusting in the Almighty," said the Bishop.

"To talk bluntly, it means we trust in the rubber Johnny," said Wunderwear Woman who had slowly emerged from within Isabel as the conversation had progressed.

All was quiet for a while.

"Isn't that ignoring the woman's role? The cradle of humanity? The bearer of children? The union of man and woman?" exclaimed the Right Reverend sanctimoniously.

"Well why don't you and the nuns get married then. Go and get shagging away yourselves instead of lecturing other people. Don't go making up rules that are not in the good book," cried Wunderwear, getting more worked up.

"A woman's not a bloody baby factory you know!? Even nature realises that. I chuck out an unfertilised egg every month, twelve a year but I can't get pregnant twelve times a year and have twelve babies can I? When we do we make humans not frog spawn. Wake up man, wake up. God gave us a choice. You made yours, we make ours."

O'Halloran looked at Mom, "what do you say to this Maria? What do you think of all that?"

"One thousand percent behind my daughter in law," Mom said forcefully, "for crying out loud if we had trusted in god every time my randy animal husband rolled me over then I'd have never got my legs closed and would have never given my womb a rest."

O'Halloran was shocked and speechless and looked to the Bishop for help.

"Maria you are an Italian born Catholic yet you sound more Irish every day," chuckled Clancy, "we are a bad influence on you to be sure. Father relax and enjoy your drink. Lance would you get your brother Brad back in here and tell him to bring that cognac with him? The devil smuggled it out again. Lance and Isabel will get round to it in their own good time but I don't think I'll be marrying the Mother Superior this side of Christmas."

"Where's Isabel gone now," asked Jeanette, "she was here a moment ago. What's she up to?"

"When she's in her Wunderwear Woman role there's no telling what she's going to come out with," said Lance.

"Who the hell is this Wunderwear?" asked the Father.

"It's Isabel in her up front, confrontational, save the world mood," explained Lance.

Wunderwear had gone to the bedroom, rummaged under the bedclothes, found what she wanted and rushed downstairs into the room.

She barged in proudly displaying a rubber Johnny and cried, "this is it. To you this is an illegal thing and it's a used one. Well used actually. It's a wonder it didn't get worn out last night before it finally fell off."

The two God's representatives glanced at it for a moment then calmly lifted their glasses for another refill of fine cognac and toasted the family.

She barged in flourishing a rubber johnny—obviously well used.
"It's a wonder it didn't get worn out last night before it finally fell off"

The Tiger Mum

"Florida these days is like a fucking United Nations," Brad blurted out one afternoon," if it goes on like this we Americans will have to have another war of Independence. I can hardly find anyone who speaks fucking American let alone Italian."

"They speak South American though," smiled Jeanette.

"What damned language is that? Inca or Maya or something?" snarled Brad.

"Nope, just Spanish," she replied.

"So what? What did the Spanish ever do for America? They came, they saw, they conquered, they stole everything in sight and left nothing behind except the language and poverty. When they want a decent life they come north. Big deal."

"And just what did we do different, big brother?" she said.

"Oh we came, we saw, we conquered all right but we put in more than we took out. We made the world safer for democracy, most of them can't even spell the word," said Brad.

"Maybe not but perhaps that's what they came for. They may not spell it but they understand it. They came for a better chance, let's give it to them. That all right with you?" Jeanette said patiently.

"Yeah, 'spose so. Just tell 'em to learn to talk American, that's all, and work a bit. Forget welfare. They know how to spell that don't they?"

"I've got a friend who works more than a bit you know," Mom interrupted, "she's Chinese."

"Jesus, another one. See I told ya, they're all over the fucking place. Not an American in sight. What's this friend do? Takes in laundry I bet." sneered Brad.

"No actually," smiled Mom, "she's an economist at Bank of America." Silence.

"She's got two children, in their teens. Her husband, he's Chinese too, works for the European Commission in Brussels," Mom continued, "she also plays cello in a local string quintet."

Jeanette burst out laughing," got you there Brad. Betcha can't spell quintet let alone say how many are in one."

"Not musical am I? That's why ain't it?" Brad said sulkily.

"More like you're dumb and prejudiced," Jeanette said as a rejoinder.

"Come off it you two, give us all a break. I don't care where they come from as long as they want to believe and behave like us and not try to make us believe and behave like them. Obey our laws, not theirs. If they don't want to do that then why come here? They should put their own country right not try to put ours wrong," Lance said as he stretched and loosened up in the huge armchair that had enveloped him and Isabel.

"Hey, I'm a foreigner and I don't speak American. I speak proper English but don't send me home," came Isabel's voice from the depths of the chair.

"We won't honey, we love you," Mom said, consolingly, "you're a worker darlin'. We've never been so far ahead of ourselves."

"Anyway when do we meet this genius friend of yours?" Lance asked, "or is she too good for us?"

"Yeah Mom, how did you meet her? You studying high finance these days?" asked Brad.

"Yes, if you really wanna know. We met at an investment seminar. We got a lotta loot saved up so I stuck my nose in at the bank. Asked them who I could trust these days as most banks were run by crooks. I told 'em I wouldn't trust 'em with my kid's piggy bank. I've never had much to do with crooks, no interest really, but this banking crowd are not only greedy crooks they're totally incompetent," Mom said firmly with a grim, determined look on her face.

"So what was the result?" asked Lance who was growing very curious. Mom at a bank meeting? Wow.

"Not much actually. They haven't got a clue. They think that if they carry on carrying on in the same way doing the same things they'll eventually be all right with a bit of luck," said Mom, "damn dumb clucks if you ask me. They don't make anything. They try to use other people's money to make money. That's all they do and they don't even do that well. They're all little Ben Bernankes trotting out useless platitudes in a big headed way. They think that issuing banknotes, government securities and controlling interest rates then buying them back up is the be all and end all of economics. I tried to tell 'em it's work and manufacture thats the answer. Get people back to work and make things that people can buy. That gets an economy going. Waste of time. They're all too thick, opinionated and set in the same mould. Need a darn great shake up, that's what."

"Mom, where did all that come from?" shouted Jeanette

"From one or two others at the meeting. The seminar was good. The results were crap," Mom chortled, "got great ideas during the day but none were allowed into the finale. It all got watered down as usual. About as inspiring as a non-alcoholic cocktail. Caught a little of the taste but none of the kick."

"Right, got that, but where does your Chinese pal come in. Was she one of the rebels?" asked Lance.

"Nah honey, she was one of those from the bank. I just thought she was a sweetie so we got to talking," said Mom a little dreamily, "we're meeting for coffee tomorrow evening at Starbucks. You can come if you like as long as Brad behaves himself. Whadya think?"

"Wouldn't miss it for the worlds," they all cried out together.

"Bankers huh!? I reckon Wunderwear Woman ought to go along too," thought Isabel.

They were settled in comfortably with Lattes the next day when Mom glanced up and said, "ah, here she is now."

Whatever differing expectations they had originally the lady immediately dispelled them.

Whatever differing expectations they had, the lady dispelled them.

She was young, bright, slim and charming.

"Wow," thought Brad, "why can't all immigrants look like this. I'd make her legal."

Lance had caught Brad's expression, "down bro'" he smiled, "she's married with a son and daughter. You've gotta go hunting in another neck o' the woods."

"How old's the daughter?" Brad asked hungrily.

"Old enough to see through you right enough," Mom grinned as she greeted her friend, "Hello Mai, good to see you, thanks for coming. This is my family, for what they're worth. We're all American out of Italy except for that one there who claims to be English but doesn't speak it too good. We'll translate for you if you don't get it."

Introductions were soon over and mint tea ordered for Mai.

36

"How old is your daughter," Isabel asked pleasantly, "is she here in the States?"

Brad eagerly leaned forward.

"She's eighteen and here in College. She's studying engineering," replied Mai proudly with an American accent, "she's coming along later. Hopefully you can meet."

"Yep, oh boy, I surely hope so," Brad said a bit too passionately, "a chick who can mend cars, paradise."

"She won't be mending cars, that's a job for a lowly sort of mechanic," Mai said icily, "I haven't given up so much for her to do mundane work like that for gods sake."

"We do mundane work like that." said Lance ominously, "we mainly fix boats but can do cars. Keeps everything going. Folks can get on and earn their living and we can go fishing and distributing."

"Well my daughter isn't going to just earn a living. She's going to get on and see the world. She's a high flyer I saw to that," Mai pronounced firmly.

"How did you do that then gal?" Mom asked, "motherly love and guidance was it?"

"You could say that, there was love and guidance for sure, but it was the firmness and discipline that made the difference," she replied, "No silly computer games, no television except for two hours a week strictly chaperoned, no fancy clothes or hairdos and no rock and roll stuff. Classical violin lessons everyday with hours of practice and after hours study. Children don't understand, do they? We know what's best for them, don't we?"

"Don't know about that honey," Mom said curtly, "their pop and I brought them up best we could together, got them through school and college, guiding 'em for sure, but letting them work most things out for themselves. I got one married, one divorced and one in limbo. He ain't gay but he ain't got it all there either. We figure he'll get there in his own time."

"My daughter will never get divorced, I'll make sure she get's the right man in the first place," stated Mai forcefully, "one who will understand Asian values. You Westerners have lost your values, you are too soft on your children, too liberal and casual about everything."

Wunderwear Woman was starting to emerge. Isabel tried to control it but this was too much.

"Excuse me," interrupted Wunderwear, "You are so uptight I reckon your knickers are in one hell of a twist so please enlighten me. Just what are these Asian values?"

"Well we remain close as families, take care of our parents and old people, husbands stay with their wives and parents obey their elders," Mai said with superiority edging into her voice.

"Funny that though," laughed Wunderwear, "I'm sure they might try. You see I worked around the world in advertising and all I saw in Asia was devastating poverty and disease for most of the population. Some lived very well but it seemed that there wasn't much of value being spread around. Men didn't seem very interested in their wives and were unfaithful whenever they had enough loot for bar girls or karaoke. The whole setup made them seem very selfish and inward looking. Poverty does that you know."

"I can imagine," said Mai in an offhand manner, "that's why my daughter will never experience anything like it. Anyway there's poverty here you know and your families don't stay together very often."

"That's because we have to be mobile and get on our bloody bikes to get a job, don't we? We don't hang about in villages expecting everything to come to us. We bloody well have to go out and get it," cried Wunderwear, "most of our parents value their independence rather than dependence. It's usually their choice. We look at our kids in a different way that's all. Anyhow you've moved around haven't you? Where are your parents? In fact where is your husband? Do ya know what he's up to now, this minute?"

"Yes in fact I do, Belgium is eight hours ahead so he's safely tucked up in bed," she said smugly.

"I don't doubt it," smiled Wunderwear, "the point is, who with!!?"

Before Mai could erupt, although she was obviously boiling, she exclaimed, "oh, here she is, here comes my daughter Luana."

They all looked up expectantly. If they were surprised at how Mai looked then they were even more so with the daughter.

They blinked. "No," they thought, "can't be. Must be a mistake. Where's the daughter? This is never her. Mai is having us on."

Coming towards them with a smile all over her face was a sort of punk rocker designer style girl.

She was full of confidence, much larger all round than Mai. She scooped her mother up in her arms, dumped kisses on both cheeks, sat her back down and said, "Hi," to everyone.

Brad was openmouthed.

The others were stunned.

Frankly even her mother seemed discomforted.

This was no done down girl, this young lady was making her own statement.

She was introduced all round.

"How's the violin lessons," exclaimed Brad, who plodded on in spite of frowns all round, "playing at the Philharmonic yet?"

"What?" queried the girl looking a bit puzzled, "don't care for the instrument much. Didn't get much pleasure from it actually, nor did my brother. Why? My mother hasn't been going on again has she?"

"Yes I'm afraid she has. Don't reckon much to us Westerners as she choses to call us. Reckons we're too casual and lazy or sumthin'," smiled Lance amiably, "thinks we are happy to settle for second best."

"Huh, the only things I remember continually coming from the East are Barbarians, Great Plagues and different types of Flu'." cried Brad, "dunno nuthin' 'bout values. Seems I read about poisoned food, toxic toys and Government harassing people all the time, especially foreigners."

"Well you are ignorant aren't you?" laughed Mai, "never heard of gunpowder and stirrups I suppose?"

"Well we don't need stirrups in cars and planes do we and as for gunpowder why invent something that blows people up. I'd rather invent television, films, phones and everything else. Anyway I ain't that dumb. The Indians probably invented the stirrup because they got so drunk with Tiger beer they kept falling off their horses playing polo. As for gunpowder we ain't sure who actually invented it but we do know that it was the English who played a dirty trick on the mediaeval French cavalry by being the first to use artillery in warfare. Scared the shit out of everybody."

"My mom doesn't understand creativity," said Luana, "she only knows discipline and you must follow the rules. Love her to death and always will but she's living proof that parents often don't know best. They can only do their best. They call themselves Tiger Mums but the correct name is Control Freaks."

She carried on talking to the group as though her mom was not there. "Poor things. They were controlled themselves as kids, then had an approved marriage but couldn't control their indifferent husbands. So in desperation found that their children were ideal candidates. They always use the pathetic excuse that it's only for the sake of the children"

She glanced across at her mother, "my brother freaked out at sixteen and I thought that I liked that fine so I hung on and did it too. This is me now, just me. It won't be me for ever but it will do for now."

"Well Miss Smarty I got you to college didn't I?" replied Mai.

"No Mom, **I** got me to college. **Me!** You put hours of violin lessons in the way," laughed Luana, "oh my god, those violin lessons and the hours of study on things I didn't need. I'm not totally sure about being an engineer but I fancy it a lot more than being a banker, doctor, lawyer or dentist."

"When I got to sixteen I rebelled. This is me now, just me.

Jeanette leaned across and said softly, "enough about kids. What about you Mai. You gotta big job in the bank. Whadya do there?"

"Oh nothing really. I work in the investments department. I head up a planning division," Mai said modestly, "try to work out where the economy is heading and where we should put our money."

"Wow, how do you know that? How do you work that out?" asked Brad, "got a crystal ball or sumthin'?"

"We need one actually," smiled Mai, "it would help a lot at times. It's not that there's not enough information, it's that there's too much. Most of it is contradictory. It's all 'if this' and 'if that' and no one knows which 'if' will be the right one."

"Yeah but why all the obsessive focus on the New York Stock Exchange?" asked Lance, "it's become just another investors gamble like gold, currency or the lottery or whatever. The stock prices don't reflect production, employment and progress any more. It's just about money. The owners have issued and sold the shares and mostly lose control of the company they've built. Most investors aren't interested in the workforce or products are they? They're only interested in the share price and dividends. Means the managers are diverted from their real job. They keep their jobs by trying to keep the investors happy and they do this by pissing off the work force who make the fucking stuff in the first place. It's a system but not a good one."

"I wanted to say that," exclaimed Wunderwear, "it's a bit cockeyed that the gamblers control the economy isn't it?"

"Not really," said Mai, "don't forget they take the risks. It's their money they're risking."

"But it's often not their money is it? It's someone else's. So a miner, steel erector, firemen, policeman, medic and soldier don't take risks. For god's sake woman they risk their bloody lives every day and you talk about risks," shouted Wunderwear, "Seems to me it sorts out the greedy and selfish from the rest of us ordinary folk. We little people you look down on because we're not filthy rich are the one's who make it safer and possible for you other lot. A guy who's just paid out $30 million for a new personal jet screams in pain that a fireman or another worker wants a 10% raise. Think about it. Get real! The systems fucked up." She took a deep breath.

"But even if the richest man in the world gave all his fortune away it wouldn't make any difference to the world's poor would it? It's not enough," said Mai convincingly.

"What a stupid argument," cried Wunderwear, "of course it's not enough but a more equal distribution of everything else would be wouldn't it? If most of the people on this planet just manage to survive on the pathetic 10% of wealth just imagine the difference a 50% share would make. Clean water, sanitation, electricity and education.

"I didn't realise that you were pinkos, socialists or whatever," Mai said, "I mean how can you believe all that?"

"Oh for Christ's sake, we're none of that. What's up with you? As soon as anyone criticises the goddamn capitalist system you trot out that we must be commies or whatever. Reds under the bed stuff," shrieked Wunderwear triumphantly, "is that all you got? Is that your argument? Pathetic ennit?

We are supporters of democracy, the free market and any necessary acquisition of capital. Got it? We don't see much of a free market when 10% of the population owns 90% of the wealth. That's unacceptable capitalism not acceptable capital. We're Christians not Communists, we're social reformers not socialists. You call yourself an economist and can't see that it is storing up one hell of a problem in increasingly educated populations. Where did you study?"

"Harvard actually," Mai said in a superior manner.

"There's the problem then, ain't it?" interjected Lance, "they just turn out clones for the status quo. No point in trying to think out of that box they put you in, is there? What they teach is where you stay. In the past"

"Well, WE had a civilisation when you were living in caves. Perhaps WE have a more mature view," said Mai quietly.

Wunderwear could hardly stop exploding. She tried to restrain herself. "if I remember correctly that remark came from a certain First Lady in Formosa, as it was then, who didn't have any other answer to give against accusations of incompetence and corruption. It has been repeated by ignorant people ever since.

As soon as anyone criticizes the capitalist system you trot out
that they must be commies or whatever. Reds under the bed.
Is that all you got? Is that your argument? Pathetic!

The world wouldn't be where it is now if it wasn't for Egyptian,
Persian, Greek and Roman civilisations that were preserved and improved
by middle eastern Moslems for years until the European Renaissance
took over. It was magnificently saved from dozens of destructive Eastern
Barbarian invasions. You were nowhere, like nowhere. You've been
playing catch up and copycat ever since. What you called Civilisation we
called the Dark Ages. All a matter of how you want to look at it really.
And just for the record there wasn't a fucking cave in sight at the time.
Those wonderful paintings in them were done thousands of years before
the East even knew where they were let alone who they were."

"I feel a little outnumbered here," Mai said, obviously upset, "I think I had better keep quiet."

"No woman, don't be that way," said Mom, "we're in America. We can all have different views without worrying about being arrested. This is the land of the free. At least until those political correctors come along," she laughed.

"You're a lovely lady Mai but you use your head too much and your heart not enough. Chinese people are great"

"But you're a banker. Not good," said Wunderwear, "twice in eighty years the banks have reduced the world to poverty and that's two times too many.

No trust anymore. Those MBA's can only think up get rich quick schemes and don't worry whether they're legal, moral or who they effect. Fuck running the world's economies successfully."

"I reckon the Lattes must have had double doses of caffeine," Jeanette chortled, "good job the music was loud enough to drown us out otherwise we would have been thrown into the street for starting a riot."

"Do you mean we haven't started one? I'm disappointed," said Brad, "come on let's move onto a bar and get the beers in. Mai, my sweetheart, they even serve Tsing Tao."

"Alright," said Mai, "but my drink's a bottle of champagne. You don't know the half about us Harvard types."

Guys, Gays and Dolls

Mom wanted to visit. She was in the mood to cement family ties. Her brothers lived in Italy but her sister Vera was local.

So Vera was the target.

Mom wanted a full turnout, no excuses. Sunday after church, everyone on parade. Full dress.

Mom looked them all over very closely.

"Do we pass muster?" laughed Lance, "are we good to go?"

"Don't joke. Vera and her lot will be in their usual nitpicking mood. Shaving under your armpits is an example of loose living to her," replied Mom.

"What, her son is a promiscuous gay arrested for prostitution, her daughter has left two children with her to run away with drug addicts on several occasions and she has a husband under protective custody in a hostel because she beat him up," Lance cried in frustration.

"That's why she looks down on everyone else. Don't forget that nowadays they're not the criminals, they are the victims," explained Mom, "they reckon that all us innocent, ordinary suckers are just asking for it so they say don't blame them if they sock it to us."

"What a screwed up point of view," said Jeanette, "it's bad enough that the criminals make up excuses for what they do but when decent people do it for them then no wonder everything gets worse."

"Come on, let's go," said Mom, "let's go and hear all the excuses from the horse's mouth, or in Vera's case, the hippo's mouth. Hope she's had a shower and her teeth fixed."

They went.

They drove their truck down into an area of Miami that was nothing like Miami Beach. In fact it wasn't much like Miami either.

This was poor, deprived, unemployed and no Hopesville all rolled into one. Vera lived in one of the more derelict properties although that seemed a bit of an impossibility.

As if reading their minds Mom said, "yeah, you got it! Bad eh? If there's one thing our Vera's good at it's being bad. She's a champion at being worse off."

"But the whole family could have a reasonable life if they all worked and lived together, couldn't they," asked Isabel, "I mean what about her husband? What does he do?"

"Keeps out of sight, that's what he does," said Brad, "he lost his job on the cruise ships because of too much time off and sick leave. He lost several jobs that way so Vera beat him up."

"Well I suppose he deserved it then, didn't he?" said Isabel.

"Sort of," Brad chuckled, "he had the time off because he was recovering from the beatings Vera handed out. She beat him up when he worked and beat him up when he didn't. In the end he did a runner and got a restraining order. Vera's threatened to kill him on sight!"

"And we're going to pay her a visit," smiled Isabel, "do we have a swat team standing by?"

"No need, she knows we stand together and she also knows we pay the rent," said Lance, "mess with us and we fight back and dump the lot of them on the streets."

"Hah! But you have to realise that Vera being nice is like looking at a basking shark. Acts docile but is ready to snap up anything," Jeanette said.

They drew up on what remained of the short driveway. They parked between a car chassis without wheels set up on concrete blocks and a pile of worn out well used rubber tyres.

The steps up to the front door were intact but lopsided. They collapsed left.

"God help them if they try to get in when they're drugged or drunk," murmured Isabel, "they'd never make it up those steps."

"They don't use the steps. The front door hasn't opened for years. Vera barred it to stop debt collectors. They use the back door. That hasn't got any steps so they're okay," said Lance reassuringly.

"But how do they get up there then? That door's a little too high to reach without them," exclaimed Isabel.

"Easy, girl. Dead easy. They use two different size upended buckets. They've never missed a step drunk, drugged or sober," explained Brad.

While they were observing the buckets Vera appeared and opened the door.

"Well, well, well," she snarled, "who we got here? Come to see how the animals live then have yah?"

"Well," said Isabel, "what a nice welcome, very nice I'm sure."

"Vera doesn't do nice," said Brad, "that's as good as you get."

"Nice, nice? Who's the fancy broad you've brought with ya? Lady high and mighty," smirked Vera.

Isabel kept quiet but knew that Wunderwear would be bursting out before very long. She could just feel it.

So did all the others.

They couldn't wait.

Frankly that's why they had come!

"Whadyahangingaroundoutthere for?" yelled Vera. She always yelled and often made whole sentences sound like one word, "if you're waiting for Father Christmas thenyougotafuckinglongwait. He don't come here. Don't give us nuthin'."

"Probably because you don't do nuthin'," grinned Lance speaking quietly, "come on let's get inside before the whole community knows where here. I'd like to see a whole set of wheels still on our car when we leave!"

"Coming Vera," Mom called, "just as soon as we work out the bucket system. We have a different use for buckets in our house you know?"

"Yeah our bathroom's fucked up too," shouted Vera.

"Not what I meant," Mom muttered, "never mind."

They staggered into the living room.

It was surprisingly clean.

The amazement obviously showed on their faces.

"Whytheshock?" asked Vera, "ain't ya ever heard o' black plastic bags? We had a clearout yesterday. The place was looking like an absolute

shit'ouse. We ain't like the rest around here. Fucking shit 'eads and peasants all o' 'em."

"Yep, you sure got class Aunt Vera," said Brad risking a dangerous look of suspicion that shot across his aunt's face.

She let it pass as a young woman drifted into the room holding a small girl by the hand. The little girl seemed apprehensive and reluctant.

Vera visibly mellowed. In a less coarse character it could even have been described as softened but in Vera's case that was not possible.

"Why hello sweetie," she cooed, "people this is my daughter Merry and my granddaughter Honeybee."

They had all met before but introductions were necessary as they were never sure which Merry they were going to see. She adjusted to whatever boyfriend she was screwing around with at the time. This time she was a rather coy ponytailed blond with glasses so big and dark that maybe her skin was sometimes kissed by the sun but her eyes for sure never saw daylight.

"Wow," exclaimed Brad, "look at you. You look so young and innocent."

Merry smiled shyly as Vera interrupted, "yeah, her latest fella, Avatar, he prefers virgins."

Mom snorted, "a virgin!? A virgin for Christ's sake! She was never one of them. Anyway she's gotta kid. Is the guy blind or something? Must be a devout catholic to believe in virgin births."

Vera roared, "no, he's just dumb. All her guys are dumb."

"But Avatar," Lance laughed, "The guy's called Avatar? Seriously? He's called Avatar?"

"What's wrong with that?" Merry asked curiously.

"Avatar is a God who returns to earth from time to time," explained Isabel, "is the guy Hindu or something?"

"No of course not. He's not a cripple," she said, "he's a bodybuilder, it's all there. Nothing missing. I've had a good feel around."

"A feel around," shrieked Jeanette, "haven't you looked for goodness sake."

"No," Merry said indignantly, "I always keep my eyes shut. What do you think I am? A cheap slut or something?"

Silence.

Maybe her skin was sometimes kissed by the sun
but her eyes for sure never saw daylight.

Then, "hello little girl, how are you today?" asked Isabel bending down low in front of Honeybee.

The girl twisted around, looking down, held the edge of her skirt in one hand, glanced slyly up, stuck out her tongue and blew a loud wet raspberry.

Vera shouted out in glee, "ain't she just cute? Ain't she just sensational? Oh mah gawd she's so bright. So cute. Don't know where she get's it from."

"Where kid's always get it from," Isabel said disgusted, "shitty, spoilt little brats get it from their parents."

"Now see here," started up Vera.

"No you see here," interrupted Wunderwear Woman, "if you don't get a hold of this one then she'll be ruling you and in a few years you'll be asking where it all went wrong. I bet she's been chucked out of a few little kid's schools already and you're making excuses for her. Bet you reckon it's all the other kid's fault."

Before Vera could explode Brad intervened, "what do you mean by saying they'll be asking where it all went wrong? How is this lot ever going to know?"

Everyone burst out laughing except for Vera and Merry. Honeybee still tried to look cute instead of petulant. She failed.

Before Vera could start a full scale riot another figure slid into the room and said," hi everyone."

"Hello," Lance said to Vera's son Hercules, "how's things pal?"

"Not so good bro'," Hercules said dismally, "Ajax has been taken away."

"Who's Ajax?" asked Wunderwear, now fully settled into her role, "is it a cat or dog or something?"

"You trying to be funny or what? Insinuating something with that dog thing?" snarled Vera, "You saying Ajax is Hercules's bitch? They're partners see. They're a couple. You need to watch your mouth woman!"

"Whoops," laughed Brad, "what's he done?"

"Assault," said Hercules.

"What for? Some guy called him a nasty gay name?" asked Brad too innocently.

"No worse. Some guy thought he was straight and hitting on his girlfriend. So the guy took a swing at Ajax. Well you know Ajax. (they didn't!) He can be such a brute. He demolished the guy first and the girl second. He was truly magnificent until the police hit him with a taser. A sergeant looked me up and down and said 'sorry babe, his dick will be out of action for a while, go and suck a lollipop' and walked away laughing. How droll."

"Yep, you guys sure do have a cross to bear, don't you?" said Lance.

"Except Jesus wasn't gay," moaned Hercules, "would have made it a whole lot different if he was!"

"Oh boy, I don't even want to go there," responded Mom, "he died to save us all you know? Forgave all our sins."

"Tell that to the Homophobes. They reckon Jesus missed us out," Hercules complained loudly.

"Well of course he did. He wanted to save the world not make it sterile," shouted Wunderwear, "if we were all like you we wouldn't be here would we. We'd never reproduce. There'd be no little kids for you to drool over, no one for same sex partners to adopt. Just shut up, get on and

live quietly how you want to live. In the meantime we'll live how nature meant us to be."

"Huh! What's natural? I've seen cows getting up one another," said Hercules.

"So what, they were frustrated weren't they," cried Wunderwear, "they can't masturbate can they for god's sake. That would be a trick wouldn't it?

So the silly cows do the best they can until the bull is let loose and then they can't get enough of the real thing. Poor things only get one bull now and again. Anyway you don't see bulls trying it on one another do you? That would give a new meaning to getting horny wouldn't it. You'd end up with more than one hole to put it in." Wunderwear Woman paused for breath.

Jeanette thought she should cool things down a little so she glanced at Hercules and said, "how about you. Not been arrested lately I hope?"

"Jesus wasn't gay," moaned Hercules, "would have
been a whole lot different if he was.

"Thanks for asking," he said, "not that it's exactly a friendly question, but thanks anyway. Actually since I met Ajax I have been a changed person. He keeps a close eye on me. Makes sure I don't stray. I couldn't resist the temptation once or twice and he made it clear that he couldn't accept it."

"He put you right on that did he?" asked Jeanette.

"Yep, he broke my jaw and two ribs," said Hercules wryly, "I've been faithful ever since."

"Woosh!" Lance erupted, "so he's obviously the male partner then?"

"No don't be silly. He's just a hopeless big girl. Loves me to really give it to him. Such a softy," Hercules mused slowly, "I miss him."

"On that romantic little note I reckon it's time to go," Mom said firmly, "come on we've taken up too much of these people's valuable time. Vera, I'd love to say it was wonderful to see you but it wasn't. It was very interesting and educational though and for that we thank ya. See ya when we can. You take care now."

Mom collected her brood together said their goodbyes and escaped.

Once in the truck Mom said emphatically, "too much sex and not enough love in that house."

"Can see that with Hercules and Merry but not Aunt Vera, not the sex," Brad chuckled mischievously, "who wants to fuck a dragon?"

"You'd be surprised," Mom said firmly, "she picks up lots of older guys in bars and they daren't say no. In fact she makes them go down on their knees and beg for it. That gal can be a real ball crusher. She's very demanding. The neighbours watch out for when she takes somebody home and then wait for the medics to turn up later. They nearly always carry the guy out. Very few are walking. Some are crying. What a gal!"

"No wonder her husband ran for it," said Jeanette.

"Amazing you know. Vera adored him really. He treated her as though she didn't exist and she loved it. Thought he was a challenge at first," Mom said with wonder in her voice, "I'd 'ave killed him long before she got around to violence, the thoughtless bastard. Anyway Vera wants to be buried next to him when she dies. I reckon that's just perfect. They'll be together at last."

"What, you mean husband and wife?" asked Brad.

"No," laughed Mom, "I meant Vera's legs!"

52

The Visit

Brad was still going on about the gays, "I don't give a damn whether they are gay or not. Shouldn't be condemned or threatened, but don't stuff it to us or the church. I mean go and get married for Christ's sake, like millions do everyday, but don't force the church to do it when it's against its basic religious beliefs. Everyone is entitled to their own opinion. Forcing a different belief on someone is all wrong if you ask me. Hardly creates understanding and tolerance does it? I'm not homophobic. I'm just the usual hypocrite forced like the majority into verbal acceptance of everything around me. Not allowed my own opinion. If not some poor demented prick will send me hate mail."

"If you ask me I reckon they do it on purpose," said Lance, "make people angry, get in their face and then complain that they're being persecuted. Don't know why they have to be so up front."

"Yeah, you'd think being gay they'd come from the other direction wouldn't ya?" said Brad thoughtfully.

"Oh no," Jeanette chuckled, "come on guys, change the subject."

"Well I've got a change of subject right here and handy," said Isabel, "checked my email and found that someone I know is coming to Florida and wants to visit."

"Hey, Isabel is getting a friend from England. That's great. Is she a close friend?" asked Jeanette.

"Close fiend more like it," Isabel chortled, "You know that old saying 'keep your friends close but your enemies closer'? Well this one you'd need to keep real close. Hmmm, come to think of it, maybe it's the other way round. Anyway with Samantha it doesn't matter. If you asked her are you friend or foe she'd just say 'yes'!"

"And you want to see her, I mean, why?" asked a mystified Jeanette.

"Well basically she's only coming expecting to see me really fucked up, drugged up, drunk and in need of rehab living with peasants," smiled Isabel, "I truly want to disappoint her."

"Gee, she's a real friend all right, ain't she?" said Jeanette whimsically, "wish I had friends who cared about me like that."

Isabel took a good look at her and said, "if you're serious and not putting me on then I'm booking you in for a brain transplant. Get real gal, get real."

She walked out.

"Well what's wrong with her then, big miss pushy?" asked Jeanette in an injured tone of voice, "where does she think she gets off?"

"Wait till you meet the bosom buddy. Wait till she arrives and you'll see for yourself," said Lance, "from what I've heard she's quite something."

One week later she arrived.

Isabel met her at Fort Lauderdale airport.

Samantha came breezing out of arrivals looking as fresh as ever.

"How does she do it?" thought Isabel, "she's just had a seven hour flight."

She went forward to help with the luggage only to see a porter following through with six cases of Louis Vuitton on a trolley.

"No," said Isabel, "please God no. She's only coming for a short break. Please tell me that it's all for some one else."

It wasn't. This was what Samantha need on a short break.

"Hello Darling," they both said simultaneously, as they hugged and air kissed twice.

"Was your plane late? I was here earlier. What was the delay? It didn't come up on the board at all," asked Isabel all in one breath.

"I was the delay darling," Samantha cooed, "couldn't face America looking like a rumpled tramp could I? So I spent an hour in the Spa. Basic but good enough. God knows where the attendants came from. Couldn't understand a word of English even when I shouted. Third

World in Fort Lauderdale. Not good enough dear, not good enough. Miami yes, Fort Lauderdale no."

"That's what I meant to ask you," said Isabel thinking that although she wasn't rumpled she still looked a tramp, "why Fort Lauderdale?"

"More upmarket darling, more my style. Miami is so kitsch. No offence but I won't be staying with you in your condo. All those wannabes around. Old ladies rattling their jewellery with young beach bums rattling their testicles. All past their sell by date. Too much bling, bling for me. I am at the Grand Hyatt here, just up the road. Far more suitable."

"Oh, right," said Isabel, "I have the truck outside in the car park. Let's go."

Samantha didn't move.

"Come on Sam," Isabel urged, "I've been hanging around here long enough."

"My name is Samantha if you don't mind and I am not moving because did I hear you say truck?"

"Yes truck, as in pick up truck, as in picking you up truck," grinned Isabel.

"I don't do trucks," said Samantha frowning, "I prefer to leave Sweet Home Alabama stuff to the movies. You know where the dumb blond leaves the boring hick town for the bright city lights. Does well, finds sex but no love so returns to hick town to find true men. And there they are, all the genuine good old boys who don't do a stroke of work, play pool and kid around all day and night, yet own pickups, great boats and a lakeside home. All the dumbos walk off hand in hand having fun leaving behind those synthetic smartass guys in the city to actually earn a proper living. Yuk, yuk, yuk. I'm sorry I don't go along with Hollywood and Oprah. I fell in love with the true America and the real Americans, not the cardboard cutouts."

"A whole lotta real Americans got trucks," said Isabel, "and a lot more would like one and they would say, just like me now, 'fuck you, go and get a cab'! I'll call you later."

Isabel walked off leaving Samantha stranded with her porter and luggage.

The porter was open mouthed. Samantha's was clammed shut.

Great friends!

Isabel got an email a little later.

"What's wrong with you then miss shirty. America gone to your head?" Samantha.

Isabel phoned back.

"Nothing wrong with my head. I had a pain in the arse. You!" said Isabel.

"Are you coming to pick me up for dinner, let me meet the family?" asked Samantha.

"I don't have a problem. You might. I will have the pick up truck. The Rolls Royce is in for service along with the Cadillac super stretched limo." Isabel said.

"Very amusing. All right I suppose I can slum it for one night at least. Seven thirty okay?" replied Samantha.

"Yep, fine." answered Isabel.

It was a family turnout. It was a full pickup truck.

Samantha was sitting sipping a glass of champagne.
Isabel had a feeling of deja-vu.

Samantha was waiting for them in the lobby lounge sipping a glass of champagne. Isabel was first there and had that feeling of deja-vu.

The rest of the family bundled out the truck eager to see this particular lady. Samantha rose from her chair, turned expectantly and tried to retain a cool, calm, ladylike, superior demeanor.

She failed.

"Yeah oh yeah, sexy lady," exclaimed Brad as he swept her up in his arms, "you are all my dreams come true. The name's Brad."

Samantha recovered quickly, leaned back from his embrace, beat him about the ears and shouted in a very unladylike voice, "well you are my worst nightmare, get off me you stupid brute."

The result was not what she expected.

Brad snuggled his nose in her neck and cried, "Wow, when you lean back like that my dreams turn wet. Do it again babe."

Samantha did. She leaned back further and managed to ram her knee up his crotch. Hard.

Brad dropped her as his knees buckled.

"Jesus lady, you didn't have to do that," he gasped.

"Oh yes I did, I really did," Samantha said aggressively, "how wet was that one BABE? Now who's next? Doesn't anyone shake hands here for god's sake?"

Isabel stepped up, "hiya Sam. Let me introduce you properly. Sam this is Mom, this sweetheart is Jeanette, this is my hunk of a husband Lance, and Brad, well Brad you've already met. Everybody this is Sam."

"Samantha, my name is Samantha," she growled but shook hands all round. Almost. She shook her fist at Brad.

He didn't care.

After frantic discussions about where they should eat with everyone having a different opinion they finally decided on Tony Roma's.

They all ordered Surf and Turf.

Samantha was a corporate jet setter so was comfortable anywhere except that she was reluctant to let it show. Contentment was an attitude missing from her list.

Food was easy.

She told the waitress to cut the crap and get writing the orders. "Keep it simple please. Steaks medium rare, fish to be pan seared, fries crispy, not soggy and the salad to come with the main meal, not before or after.

Okay, got it all? Good, run along now then and get it done. Oh and send the wine waiter over. Thank you."

The waitress's eyes were bigger than saucers and the family's mouths had dropped open.

Samantha looked up, glanced at the waitress and said in a very charming tone, "my goodness are you still here? Run along, we're hungry you know. We came here to be fed not gawped at. Now the wine waiter if you don't mind."

The waitress seemed about to explode but Lance winked and said, "it's okay I'll come with you and translate." He took her elbow and walked her to the kitchen.

This was a mistake because it left Samantha with the wine list.

"Right," she said, "red it is, everyone agree?"

No one said a word, only nodded.

"My good god," Samantha exclaimed loudly making everyone jump, "I wanted a wine list, not a choice of vinegar. For heaven's sake it's all American plonk. Haven't you got anything drinkable?"

"Here, give it here," said Mom, "I'm Italian. Let me chose?"

Samantha blinked but incredibly agreed.

Mom scanned the pages, making comments and asking questions.

Decisions were reached and the waiter disappeared.

"Now then," said Mom, "we're starting with a dry white, moving onto to a fine claret. I think you'll like these Samantha. The vines came from Europe at the beginning of the 20th century, took a firm hold and have been producing ever since. When some of the European vines failed some years back, do you remember, then samples were replanted back there from here fortunately very successfully? Will you do us the honour of tasting?"

Even someone as priggish as Samantha knew when they were being put firmly in their place so she agreed and graciously tended her approval.

When the food came Samantha raised her eyebrows as the waitress called out the different steak finishes. One rare, one well done and the rest medium. Lance had done the translation. They all tucked in, not talking, just munching.

When the plates were cleared and coffee was poured Lance opened up the conversation, "Samantha you are right royal welcome. We are just a normal hard working American family. Ups and downs, highs and lows, sometimes richer, sometimes poorer but always struggling on. At the

moment we are richer so live well. Not everyone lives in a grand detached house on a tree lined street with kids in college all driving big cars. We don't know anyone who owns a semi automatic rifle or pistol. We do go hunting with a legit bolt action rifle and shotgun. They are all kept secure at home. So you'll just have to take us or leave us as we are."

Samantha did not want to give way but also did not want to appear a total snob so she tried a middle route.

"I'm afraid I haven't met many normal people anywhere," she smiled, "they all try to impress that they are the most successful of all the high flyers in the world. No one does a deal like they do, no one is as smart and certainly no one is as cute, so they say. They talk about the things they've got and done rather than what they are and the things they can actually do. Amongst the rubbish are some real gems but they're hard to find. Leaves me feeling and acting rather superior I suppose."

"I'm a real gem," interrupted Brad, "a real diamond me, just need a bit of polishing. How strong's your right arm?"

"You'll find out in a minute, right under your loose jaw,?" said Samantha, but she was smiling, "this is a good wine by the way."

Mom had wisely kept the wine flowing so everyone had started to mellow.

"The wonders of wine are best known to the French and Italians," Mom said, "the rest of the world are just consumers but how about an Irish Coffee?"

"Yeah," shouted Lance, "let's get 'em in?"

"Just a minute please," said Mom, "we're not going to have the usual they serve here. In America they think a licquer coffee is a cocktail. They like to stir it all up. It should all be separate and stay separate, aren't I right Isabel?"

"Of course," agreed Isabel, "right let's have some fun. Where's the manager?"

A very attractive young lady introduced herself.

Isabel told her what they wanted, how it should be done and what it should be done with. The manager repeated it several times and said she would check back.

Everyone was intrigued, including other customers.

One of the more adventuresome customers said loudly, "hell there's more than one way to make an Irish Coffee ain't there?

"Sure," Isabel called out, "at least two ways. The right way and the wrong way. There's plenty of wrong ways. You're gonna see the right way. The only way."

They waited a long time.

Then the door burst open and two motorbike riders burst in carrying satchels.

They went straight to the kitchen and the manager appeared, apologised for the delay and said," any moment now."

She ushered out two waitresses carrying trays.

On the trays were glasses and ingredients.

The trays were put down in front of Isabel.

"Right," smiled the manager, "you are the smartypants who told us what we need and what to do. So I sent all over Miami. You got here a jug of hot coffee, a bottle of Jameson's Irish whisky, brown sugar and a tub of real, genuine double cream. Go to it. Show us how it is done."

Isabel did.

She poured the whisky in first. Then gently poured in the coffee, running it down the side of the glass, dropped in two spoonfuls of brown sugar and stirred slowly. She then let it settle so that at the bottom of the glass was a more yellow brown contrasting with the black coffee higher up. She then warmed the spoon, turned it over, held the tip close to the coffee and slowly ran the cream down the back of the spoon. The cream ran easily down the warm spoon, ran around the top of the coffee, until there was a thick white layer all over. There was the finished article. Yellow bottom, black middle and white top.

Perfect.

The restaurant erupted with a round of applause.

"Whatever you do, don't stir it," she said, "the trick is to taste each separately, with the hot coffee hitting first through the cool cream followed by the whisky. Never use white sugar and don't ever think about using whipped cream."

She sat down well pleased with herself.

But not for long.

A queue had formed and Isabel was making them for half the night.

Everybody had a great time but unfortunately after Isabel left the art of making real Irish coffees left with her. The Americans haven't got the patience of the Irish. They like everything mass produced and immediate.

"Bishop Clancy would have been proud of you tonight," said Mom.

Samantha was also happy. She couldn't resist the opportunity. She had a slightly superior smirk on her face as she said in her very best Sloane voice, "yes, Isabel, you were obviously born to serve. I would never have stooped so low as to try to please people. They should try to please me."

The family were struck dumb, except for Brad.

"What a woman!" he exclaimed, "Isabel darlin' I'm gonna fuck your fancy friend."

"Huh, in your dreams pal," snorted Samantha seemingly disgusted.

"Done that already," Brad laughed, "and you loved it."

The whole family raised their eyebrows, Samantha included.

They dropped her off at the Hyatt and agreed to call up when free. Lance had suggested a fishing trip but this did not suit Samantha. She had not got any designer fishing stuff and wasn't inclined to buy any. She wouldn't have much use for it in the boardrooms and wine bars of Europe.

Isabel received a text message.

"Thanks for lovely evening and showing me a very ordinary America. I've been meaning to ask, what's with this Isabel thing? Whatever happened to Wunderwear Woman? Samantha.

Isabel texted back, "I've still got her but I control her more these days. I only let her out on occasions. You could be one of them!" Isabel.

Samantha was forgotten for a while. Not because they were discourteous but they were very busy and a bit strung out.

Not Brad however, who swaggered about with a smug look on his face whistling the theme from the Chariots of Fire and sometimes the one from Space Odyssey when he could remember it.

He was a little put out that no one noticed even when his put on swagger became much more than just ridiculous.

Brad was put out that no one seemed to notice that his
exaggerated swagger had become even more ridiculous.

Something was going on, that was obvious but everyone was too busy
to care and Brad didn't want to come out with it unless anyone asked.

They didn't.

So he decided to tell them anyway by taking action.

Samantha turned up.

Apparently unexpected, dressed as though she was going to a
Christian Dior fashion show.

Samantha turned up looking as though she was
going to a Christian Dior fashion show.

They were all down at the fish cannery when she arrived. Production came to a halt. Mouths opened wider than the pouts on the dead fish.

"For crissakes she must be hot in all that outfit," gasped Lance.

"Don't worry, she's upper class English," laughed Isabel, "they don't sweat you know, don't even perspire, they just fake it."

"She's hot alright," yelled Brad, "and she don't fake it."

He rushed down some short steps, took Samantha in his arms and kissed her full on, tongues as well.

Isabel waited for the explosion.

None came.

Instead Samantha was giggling trying to get her hat straight and girlishly pushing on his chest saying, "not yet Captain America, put your shield up later!"

"With you darlin' it's always up, can't get it down whenever I think about it," Brad cried proudly.

The family and staff looked on in amazement.

Samantha and Brad.

Surely no.

But surely yes.

Eventually Lance broke the spell, "okay, show over, back to work everyone."

Everyone did except for the family.

Mom looked dumbstruck, Jeanette was speechless and Lance couldn't stop laughing.

Isabel was the first to Samantha who had got herself together, standing rather demurely swinging her designer handbag gently to and fro glancing at Brad from time to time with goo goo eyes.

"Samantha, Samantha," Isabel cried excitedly, "Does this mean we will be sisters in law? We'll be related."

"Don't become foolish in your middle age," Samantha said sedately, "I've only opened my legs to him not my whole life. I like a bit of rough now and then and oh my this one is rough. However with him it's not now and again, it's all the time. He's rampant. Once he gets going he can't stop. It's brutal."

She sighed, "wonderful."

"Okay if we go bro?" Brad asked Lance who was having difficulty controlling himself. Brad had scored with this snooty woman who walked as though she had a permanent smell under her nose. Fantastic.

"Great Brad, go man. Anyway where you going?"

"I've booked a room in a hotel downtown. We'll stay overnight just getting in room service. Can't wait," he crooned.

"What's wrong with the Hyatt," Mom managed at last, "won't they let you in a classy joint like that?"

"Oh they let him in all right," answered Samantha, "it seems that we're too noisy. The staff complain during the day and the residents at night. As soon as we start screwing they start complaining. So we take our business somewhere else."

"Is this your first expedition outside the Hyatt," grinned Lance.

"No brother this is our third. Appears we're the only one's who fuck so loudly. If we carry on like this we'll end up on Palm Beach," replied Brad.

"If we did it in the open air they'd hear us in Europe," smiled Samantha.

"On the fucking moon babe," Brad cried exultantly, "come on let's go, we're wasting good hotel time."

And they went leaving behind them one very surprised family.

"I don't see her as a match for my Brad," Mom said quietly, "far to fancy and la la la. Worries me that."

"Don't worry Mom, I know Samantha, she bores easily and doesn't like to lose the limelight," Isabel said re-assuringly, "being buried under and over a man in a hotel room is not her style. Not for long anyway."

"I don't want a woman like that to break my son's heart," said Mom, "he's only young you know. Just a baby."

"What!" cried Jeannette, "he's thirty one. He's older than me for goodness sake."

"Yeah Mom, he's been off the breast and out of pampers for a few months now you know," Lance said, laughing his head off.

"Not what I mean," Mom said sulkily, "he's not world wise like you and me. Can't see into things like."

"If you mean he follows his dick like most men, then tell me about it," said Jeanette, "I've had my fill of those. Even married and divorced one. Brad'll be okay."

"Hope so," said Mom, and they all went back to work. All of them smiling except Mom.

A week later Brad and Samantha surfaced.

Well Brad did. Early morning.

"What happened, you run out of hotels or something," asked Lance.

"Nope," Brad said triumphantly, "Samantha wants to go fishing!"

"When?" asked Lance.

"Now," said Brad.

"Now, like in now now?" said Lance, "where is she then?"

"She'll be along. She just had to go and get some gear first," replied Brad, "got to look the part apparently."

"I'll bet," laughed Isabel, "I wonder what part will show up."

"I wonder what parts will be showing," said Jeanette.

They all laughed except Brad. He seemed a tad anxious.

"What's up Bro', worried she won't turn up?" asked Lance.

"No, she'll turn up all right. I'm just worried which one will come. She's been acting a bit funny this last day or two," said Brad.

"Yup, that's about right," said Isabel, "bored and ready to go. That's Samantha."

"Nah, she's okay," Brad said unconvincingly, "she wouldn't go fishing otherwise, would she?"

"Did she suggest it?" asked Isabel.

"Yes she did, she suggested it. See it was her idea so it's okay isn't it?" asked Brad somewhat desperately.

"So you split. You came here and she went where?" Isabel asked.

"Shopping, she'll be here soon, just wait," he said.

So they did.

All day.

Text messages went unanswered, the phone was on message service and there was no response to emails.

Brad finally called the hotel.

Samantha had checked out that morning.

Had taken a cab to the airport.

Destination New York.

A text finally arrived for Brad.

"Great time you animal! Had enough rough, need some civilisation. Can't say see you later because I won't. Bye to everyone."

The family were worried for Brad. To them Samantha was no loss but to Brad??

"Well whadya know," exclaimed Brad, "what a gal. Sassy to the end. I never could stand sloppy goodbyes anyway. She was a great fuck though. Pity she couldn't stay another week."

They all sighed with relief. Little brother had grown up. Sort of!

"Don't know what you saw in her anyway," said Lance.

"She was easy man, easy. She thought she was so superior, better than anyone else. Hard to get," said Brad, "she wasn't though. She was the quickest and easiest lay I've ever had. Just a cheap broad actually. But don't tell her that Isabel."

Isabel didn't.

But Wunderwear did!?

The Bubble Busted

Mom, Lance, Brad and Isabel were comfortably slumped in easy chairs before the TV trying to watch a film. It was the same as usual. More adverts than film. By the time the adverts finished they had forgotten what film it was they were watching. They all made a mental note to definitely avoid the products being advertised. Stupid planners. They didn't realise they were practising reverse therapy.

Never mind. Greed is good.

Suddenly a very excited Jeanette burst in.

"He's coming to Miami," she cried, "we gotta go, we gotta get tickets. Up front, near enough to touch."

"Who, what, where and when," asked an exasperated Lance, "what are you going on about?"

"She means that Bubbly Fella," said Mom, "the copycat singer. You know, he prances around like a demented Johnny Ray, trying to be Bing Crosby, Frank Sinatra, Dean Martin and Sammy Davis Junior all in one and failing terribly.

Why see a cheap copy when you can see the originals?"

"He's not cheap Mom," replied Jeanette, "anyhow how can I see the originals? They are all dead and buried. I'd have a job buying tickets to see them wouldn't I? Be a right old rave from the grave!"

"I didn't mean live did I," said Mom rather tetchy, "you can see them all on DVD's can't you? What's wrong with that? Better than watching

some one do now something that others have done better before. Can't understand an all American boy wanting to do that."

Jeannette laughed gleefully, "he's not American Mom, he's Canadian."

"That explains it then," said Mom with a very satisfied look on her face, "I bet he calls himself French Canadian and proudly says he couldn't speak English until he was older. They all say that. It explains why Canadians are backward. Our kids speak English here at a very early age. Don't understand why they want to boast about their ignorance. I was born in Italy, spoke Italian, still can, now speak English. So what?"

"What's wrong with being French Canadian?" asked Brad, albeit a little cautiously.

It was just as well because Wunderwear Woman took over.

"Because they're nutters living in the past," she thundered, "the French lost Canada to the British, sold most of America to the Yankees and couldn't hold onto to Indo-China. The USA had to step in there and lose it forever. Canada is what it is today because of the British and the Mounties. America and Britain do so much better when the French get out the way."

"Comes of eating snails, frogs legs and horse meat," Mom said wisely, "even the Chinese don't do that, though I wouldn't want to be a dog or an insect there. The Arabs now, they know what real horses are for. They race the best in the world."

"Are you all crazy?" cried Jeanette, "what has this got to do with singing for crissakes? He's a nice young man, sings good and looks good. So okay you say he's not original but I like him and I'm going to see him."

"Go girl, go," said Lance, "you go and enjoy."

"Yes go girl go," shouted Wunderwear, "go and join the brain dead, sit with the easy listeners, get excited over nothing and pretend there's never been anything like it before. This guy has just taken over from a couple of late big bands who churned out boring, mundane, easy listening arrangements in the past of songs that had once sounded fresh and exciting. Those who wanted to remain in their comfort zone loved 'em. We called 'em the Liberace Lovies.

Don't call it music."

"Well I'd much rather watch him than American Idol," Jeanette responded.

"Well," smiled Wunderwear, "to me that just about says it all."

"Mom," Jeanette asked slyly, "you like Celine Dion don't you?"

"Wow, yeah," exclaimed Mom, "now there's a singer, what a woman. She's really blessed that one. No copycat there. A voice in a million."

"Well," Jeanette said smugly, "she's French Canadian and claims she couldn't speak English until later!"

Mom was silent for a while giving this some consideration. "you're seriously telling me she was born a French Canadian who couldn't speak English?" she said finally, "that poor girl, it's a damn good job she could sing!"

"Just goes to show doesn't it?" she said slowly and deliberately, "no matter how bad your luck is at the start you can overcome the worst obstacles in your life if you try hard enough. Good for her."

"Mom darling," said Isabel, "with you around I don't see much need for Wunderwear Woman but I'll keep her in reserve just in case."

Pro-Life

"Mom," asked Isabel, "what on earth are you doing, busying around like a tornado?"

"Got visitors, important visitors," Mom fussed, "can't let them see us in a mess like this."

"Brad!" she suddenly shouted, "Go and get a bottle of Jamesons and make sure we got some of that brandy. Not expensive mind, more medicinal. They'll never know the difference after they finish the whisky."

She went back to her fussing.

"Mom," said Isabel sharply, "we're getting religion again, aren't we?"

"Dunno what ya mean," Mom said evasively.

"Oh yes you do," Isabel said smiling, "is it just the Reverend Father or will the Bishop come as well?"

"Of course the Bishop's coming. Never passes up on the chance of a good chat," said Mom.

"Never passes up on the chance of a good booze up you mean," laughed Isabel.

"That as well," grinned Mom, "he's been in the States for ever but he's still as Irish as the day he was born. Grows potatoes in the church grounds."

"When they coming?" asked Isabel.

"Just after lunch," replied Mom, "call in all the family won'tcha? Tell 'em all to be here."

"Okay, good as done," said Isabel.

Isabel was nervous. Sure the Bishop and The Father liked their drink but there was always a purpose to their visits. What was it this time? Maybe a charity or a church renovation. She hoped it had nothing to do with her and Lance.

At two o'clock the whole family were sitting primly in their immaculate lounge looking like naughty school children waiting for the headmistress to turn up.

Isabel smiled to herself. They all looked guilty without even being charged.

A car drew up outside.

Mom peered out the window.

"What the heck," she exclaimed, "the devil is driving an old VW Beetle this time. Obviously the other one didn't put the Bishop in enough danger. The Father must be trying harder for a breakdown and the funds for a new car."

Lance went to the door, welcomed them, and ushered them in.

There were four of them, not two.

The family were surprised.

With Bishop Clancy and Father O'Halloran were a middle aged man and a young woman. The two seemed together but were obviously world's apart.

The man looked a weirdo and the woman seemed intense.

The Bishop and the Father looked relaxed.

"What was this all about?" the family thought.

"Now I suppose you're wondering what this is all about," said the Bishop, "I bet you were thinking we were just coming for a wee tipple of your fine Irish whisky weren't you?"

The family denied it vigorously.

"That's a pity then because I did fancy a taste. Just a little mind. How about you Father? Yes? Well then we won't refuse. Kind of you Maria. No our friends here don't drink alcohol. They're punishing themselves for some reason. Must have sinned real bad now. I told them to leave the judgement to God but they can't wait that long apparently."

"Welcome to ya all," drawled Mom, "we got some coke in the fridge, the drink not the drug, ha ha. Like some? Yes, good. How about you Bishop? Fancy a glass or two of coke?"

The expression on the faces of the religious duo said it all.

"No? Right! Brad the whisky for the right reverends and the coke for the others," Mom said with a wide grin on her face.

"Maria you are a torment as usual," O'Halloran said smiling, "you should let the devil do his own work."

They all settled down and looked at one another expectantly.

No one spoke first.

Everyone looked expectantly at everybody else.

The Bishop, the first to speak, held up his empty glass, "just a small refill now. No not that small! Tip your elbow a wee bit more. That's it. Fine."

Silence again.

Mom decided to speak up, "now then your Grace, what was it you came for? Does Father O'Halloran need a new cassock or something? I see he has a fine new car. Don't know where he gets the money."

O'Halloran winced.

"Now Maria don't tease. That car was young in Germany when Mozart was in pampers. We have to put our feet through the holes in the floor and run like mad to get it started. We only get a rest when going down hill and then we nearly get a hernia trying to stop it."

"Why don't you get him a new one for heavens sake," asked Lance.

"Oh no, that would never do," the Bishop said firmly, "you see the Father can't resist the drink and doesn't want to get caught drunk driving."

"But he does drink and drive," laughed Lance.

"Aye that's true but no cop in his right mind could accuse him of being drunk in charge of a vehicle. He might be drunk but he's never in charge of that damn thing. It's out of control most of the time whether he's drunk or sober.

Brad dear fellow, good man, top up my glass will ya? No more for the Father though he's got to drive you know?"

Mom looked confused so Isabel took over.

"Very reverend gentlemen would you please be so kind as to tell us all what the bloody hell you have come here for," she declared, "you have brought two people with you, settled yourselves down but not introduced them. Do I take it that they are the reason for you being here?"

"Jesus, Mary and Joseph," exclaimed Bishop Clancy, "Isabel you are a regular Sherlock Holmes. You are absolutely correct."

"Right," said Isabel, "well tell us who the hell they are then."

"Good heavens above," Clancy said, obviously flustered, "woman you are in a hurry. Can't you let a man settle a while before getting down to business? Poor old Lance. No wonder you have no children now. You'd want it over before it's begun."

"If that's what this is about then Isabel and I are off now and you can discuss it with Mom," chortled Lance, "she knows, she has the room next to ours."

"No, no no," cried the Reverend Father, "it's not about you, well not exactly. It concerns all of us. This gentleman is from Pro-Life and the lady is from Animal Rights."

"Okay," said Brad, "we're not dead yet, don't want to be, and we catch fish for a living not animals. Is that it? Soon settled then. So see you around!"

The four visitors seemed confounded.

They didn't move except for the woman squirming in her seat and the man tapping his foot impatiently.

"I don't think you understand," O'Halloran replied at last, "I'll let them explain."

The guy stood up, straightened himself as best he could and said in a self important voice, "we have come because we think you may be at risk as a family."

"Good God, do you mean we have upset the Mafia or is those Russians we saw the other night? Are they going to murder us in our beds?" shouted Mom in alarm.

"Not at all," said the guy, "we don't mean those kind of risks."

"What risks then," asked Isabel, feeling a surge of Wunderwear Woman coming on.

"Well you are all adults here, fine looking people, but there are no sounds of tiny feet. Little ones, you know, and we wonder if you have fallen into the modern trap of loose ways, of constant contraception and horror of horrors maybe even abortion," he said patronisingly, "if you are denying life to the unborn you are murdering a child."

"Oi you, how can it be denied life if its unborn? If you think that every year every one of a woman's twelve eggs have to be fertilised or else she's committing infanticide you are stark staring bonkers," cried Wunderwear, "even raw nature has got more brains than you! Go and prance up and down threateningly outside a clinic or something. Scare ordinary people to death.

You got a bomb or something in your pocket in case we don't agree with you?"

"So do you agree with the fact that women can get pregnant as often as they want and get an abortion as often as they want?" asked Pro-Life, "is that what you're saying? Can't you see it's open to abuse?"

"Of course it's open to abuse, so regulate it and control it in a civilised manner, don't ban it. Don't criminalise it," replied Wunderwear, "for instance can you imagine the added horror of a rape victim who finds on top of all the trauma that she's pregnant as well? Then when she goes to terminate with a combination of guilt and relief she finds morons like you screaming and threatening her? You are sick. You kill and bomb people and clinics who disagree with you. Fat lot of good protecting the unborn child if you murder adults. Waste of time growing up then isn't it?" Wunderwear shrieked, "you're not fit to be called human, you behave more like animals. Let's not convince let's kill! You haven't got a convincing enough argument to get what you want by fair and proper means so you try to get it by fear. No one is forcing anyone to have an abortion, it is a choice. You are the murderers, not the abortionists. You don't give anyone a choice. In fact it's an insult to the animals to compare them with you."

Wunderwear paused for breath.

The reverends held up their glasses for a refill.

The Pro-Life guy looked as though he had been kicked in the balls.

He tried a comeback," doesn't the unborn child have a right? Doesn't it have a right to life?"

"How does anyone know?" answered Wunderwear, "it hasn't even taken a breath or a drink in the real world and by the way did you notice you called it it? Anyway doesn't the pregnant woman have rights also? You want to remove her rights and give them to something that hasn't arrived yet and isn't even properly or completely formed. You chose to misrepresent everything. If a baby was ready at three, four or six months then nature would make it pop out then wouldn't it? If it does do that then it rarely if ever survives. But you don't say that do you? Basically you lie to make your case. You pretend that a perfectly ready to be born baby has been killed. It hasn't. You don't want to join in a sensible dialogue to resolve the moral issues you just want to bludgeon your opponents into submission. And you talk about rights. You bloody hypocrites."

"There are alternatives to abortion," he said.

"Yes, of course, and they should stay being alternatives," replied Wunderwear, "if you ask me I think adoption is an excellent choice, and to my mind preferable, but it should be an option, not a compulsion."

Frankly he looked as though someone had kicked him in the balls.

"I like it that you believe that animals are better behaved than humans," interrupted Ms. Animal Rights, "we could all learn a thing or two from them."

"Like what exactly?" asked Wunderwear, "it's not exactly Disney film land out there is it? In real life Bambi gets eaten! And not only by humans. Everything eats everything else. Ask an animal what's for lunch and they look around for what's on the menu. Often it's you. You are on the menu. There's no Utopia anywhere." She paused but only for a second, "it's hell in them there hedgerows woman. No sooner born than

eaten. On this planet it's either a case of being a hunter or being one of the hunted. I didn't say animals behaved better than humans. They don't. What worries me is when humans behave worse than the animals. Got it now?"

"I think you misunderstood me," said Ms. Animal Rights, "I agree with you. Animals behave as animals should and unfortunately humans often behave as humans shouldn't. I believe that we should study the animals, not experiment on them or keep them in zoos, but learn more about their behaviour and how they survive in the wild. From serious observation not just glossy magazine type animal programmes although they are helpful."

"Wow, we agree. Somehow something seems wrong," Wunderwear said with a smile all over her face.

"Not entirely," said Animal Right, "you agree with abortion. Not something that animals do is it? Most protect and bring up their young." She finished with a smarmy look on her face as though to say "got you there, haven't I ?"

"Yeah, until another stronger alpha male comes along and destroys the weaker babes while the female just rolls over in delight and submission," cried Wunderwear, "you can't have it both ways. Do you want the more civilised way of terminating unwanted or ill formed foetuses or do you want the animal style where you roll over and let a beefy hunk bump off your kids later so they don't get in the way of his?"

"I don't want living creatures tortured so that we can supposedly lead a better life," she said, neatly avoiding the issue, "they suffer so much and no one seems to care."

"Okay, I take the point, neither do I want that. So I believe in regulation, investigation and enforcement not annihilation," Wunderwear said agreeably, "what do you believe?"

"The same," was the reply.

"Good," said Wunderwear, "so what do you do if you discover a laboratory that is not conforming? You notify the authorities and expose it publicly? Is that right?"

"Yes, up to a point," came the answer.

"Oh oh, what point?" Wunderwear asked hesitantly, "isn't that sufficient to get action?"

"Not always. So we take our own action," the Animal Rights lady said firmly, "if they don't listen to us then we have to make them listen."

"How do you do that?" asked Wunderwear.

"We warn them first and if they don't pay attention then we act," she said.

"Like what?" asked Wunderwear.

"You know, you read don't you?" said Animal Rights.

"Yeah, I've read alright," Wunderwear replied, "acid attacks, bombs, arson violence and abuse? Convincing stuff. You've really learnt from the animals!

Why don't you throw paint over leather jackets as well as fur coats, Why not ban bone as well as ivory and why aren't you all vegans. Bloody load of screwed up hypocrites that's why. Most of these were legitimate businesses. Why not tackle the abuse not the use? If you ban it altogether you only make it more desirable.

"Well there are degrees of everything aren't there?" replied Animal Rights woman.

"Exactly my point," said Wunderwear, "and it's a point you extremists never seem to get or reach. Anyway what's all this nonsense got to do with us?"

"Well you fish. How do you treat your fish? Are they humanely caught, kept and killed?" she asked.

Before Wunderwear could answer Brad dived in, "don't know about the humane bit but humans catch 'em, humans kill 'em and humans eat 'em except for what we leave for the gulls. Our fleet nets'em or else we go out and reel 'em in personally. We scoop 'em up in nets, dump 'em in the tank and later when we land we chuck 'em out and them that don't choke in the air we bash their brains in. All done very humanely of course."

"So there you go your reverends," laughed Mom, "now have you got any more loonies lined up for us to talk to or shall we move on to the brandy? I see the whisky has nearly all gone. Right you two terrorists in disguise would you like another coke perhaps with a little something in it to liven it up? No. Then I'd ask you to wait outside please. We don't threaten or murder people who disagree with us in this house."

"Now then Maria," said Father O'Halloran, "we didn't mean to put you out of sorts now. We thought that maybe you needed a bit of guidance, that's all. See another way of looking at it."

"Looking at what for heavens sake?" Mom thundered, "how to kill adults rather than babies? How to kill humans as well as animals? Have you lost your common sense Father O'Halloran coming to this house

with such stories. You will never try my faith but by heck you try my patience."

Bishop Clancy spluttered in his glass. "Now, now, now Maria, don't misjudge the Father. I know his tricks. He has made a mistake because he was desperate."

"Desperate," laughed Brad, "did that cute little novice say no to him this time?"

"Don't be blasphemous young Brad," smiled Clancy, "the Father needed an excuse to come out here. He was needing a change from the wine so he came for a good whisky and a drop of brandy as well as getting me lined up to buy a new car for him. These two people were all he could think of and drum up. As good a choice as any I suppose. I loved being a bystander for a change.

Where would we be without Wunderwear to rise up for us ordinary folk? Right, I trust that clears that up so let's move on to that Brandy you're trying to hide and keep for yourself Brad, my lad. Spread a little cheer!"

"If they don't listen to us then we have to make them
listen," said the Animal Rights Lady

Down Under and Over

The Family had completed a very successful month. The catches had been larger than expected. For weeks frozen fish had been despatched all over the state and the rest had been canned. They took a breather and just supplied the local hotels and restaurants.

It also allowed the sea to recover. They didn't believe in over fishing. To them that was short termism. They took the longer view. Short term greed was not good. Longer term planning was better. Most people agreed but a lot cheated. Lip service frequently overpowered self control. After all rules applied to others, never yourself.

Mom decided on a night out. Nobody wanted to go to a fish bar. Steak it had to be.

They knew the owner well. The Family was his largest seafood supplier. He greeted them personally and ultra politely. He owed them three months invoices.

"I got somebody I want you to meet," he said smarmily, "I reckon you'll be interested. This guy is to range farming what you are to fishing."

"Not just at the moment," Lance said, "we just want to chill out for awhile. Can we catch up later?"

"Sure," agreed the Owner, "give me a shout when you're ready, okay?"

"Yep," replied Lance.

They ordered and ate in silence. A break from continuous noise was so welcome.

They relaxed, enjoyed the wine and leaned back satisfied.

"Do we want to meet this range farmer or whoever he is?" asked Jeanette.

"Nah," came the response.

Blessed silence again.

"Ello mate," came a voice from behind, "d'ya mind if we join ya?"

The Family turned their heads.

"Not really," said Lance, "we're just having a quiet family get together. We didn't send out any invitations as far as we know."

"Great mate, nice to meet chya," said the tallest of the three guys walking round the table," nah, it's okay don't get up, we don't stand on ceremony do we fellas?"

The three pulled up chairs, straddling them in a relaxed fashion back to front.

"Good to meet with you folks, kinda ya to talk to us," said the short blond one.

"We haven't said a fuckin' word yet," grumbled Brad, "whadya want anyways?"

"Well the bossman here said you were the big fisherfolk round these parts," came the reply, "where we come from we don't see too much water let alone the sea so we'd like to charter a boat. Whadya reckon?"

"I reckon you should try somewhere else, mate," Brad said emphatically.

"Now, now Brad, calm down, where's your Southern hospitality and manners," interrupted Mom, "please introduce yourself gentlemen and tell us where you come from."

"Pete, Dave and Russell," offered the tall one, indicating each of them in turn, "from Down Under you know, Australia? We're Aussies."

Mom introduced her family in turn also, "what are you doing here," she asked.

"We're over here for a Meat Exporters and Packers Convention," Dave said, "we send a lot of tucker to the USA so need to keep up with all that's going on."

At that moment a tray full of beers arrived. They were circulated.

"Hope ya don't mind but we got the beers in first," Pete grinned, "we Aussies drink a lot cos there ain't that much water."

"Not much water, for crissakes you're surrounded by it," said Brad aggressively, "Australia's an island ain't it?"

"Sort of. It's a continent and a bloody big one mate, and sea water ain't drinkable unless you're a fish," Pete said amiably, "but then you'd know all about that wouldn't ya?"

"What's wrong with Yankee beef anyway?" asked Mom, "we make enough of it don't we?"

"Nope," answered Russ, "not nearly enough. You import a lot because you don't have enough free range quality."

"You mad or something?" exclaimed Brad, "why you could travel all day across Texas and still be in the same State."

"Got it mate. We know what ya mean," Pete said, "see that cobber Dave there? Well Dave has a free range farm about the same size as Texas. Carries sheep, cattle and chickens. Can't do it on horseback anymore. Uses pickups and helicopters. My station's only about half his size and I concentrate on beef and dairy. Frozen of course. Still takes me a while to cover it. Russ is a government inspector. Poor bastard spends more time in the air than he does on the ground."

"You don't do Kangaroo or Ostrich then?" laughed Isabel.

"What! Kill Skippy? nah," Dave said, "only clowns do that, and have you ever tasted Ostrich? I tell you it's bloody tough meat. Reckon I could mend my boots with it. The wise guys race 'em, not eat 'em."

"I'll tell you what," Russ said, "you take us fishing and we'll take you riding. What about that?"

So that's what they did.

The Aussies loved the fishing. The Family pulled out all the stops and the Australians pulled out lots of fish. The excitement was incredible.

The Family had all ridden before but could not believe their three new friends.

They rode as though they had never walked.

Dave, when riding, looked as though he was a part of the horse.

They looked so comfortable that they seemed a part of the horse.

They were leaving the next day for Sydney via Bangkok. They were going to stop over for a couple of nights because they'd heard about the girls there. They were very excited.

"Is it right that they come with the beers, they look after you and fuss you around?" spluttered Dave, almost out of control.

"Of course, they sure do," Isabel said re-assuringly, "but it makes the beers expensive."

"So what," said Pete, "they're not bloody cheap in the hotel are they and you don't get the girls. As for the mini bar, well, you need a bleedin' mortgage just to open the fridge door."

"Yeah, not only that, it's the hotel bill now 'ennit," cried Dave, "it's all laid out in too much detail. You can't even watch a porno movie without it appearing nearly in bloody full on the bill. I don't want my secretary

passing my hotel bill through the accounts with 'Bouncing Boobies', 'Banged Up Gang Bang' and 'Titillating Tit Freaks' on it, do I?"

"Especially as you watched 'Tit Freaks Twice'," laughed Russ.

"Just be careful you don't take home more than you bargained for," advised Lance, "make sure the girls are clean. They love and adore you one minute and someone else the next."

"No problem, we're used to making sure our animals are healthy. We know where and how to look, don't we cobbers?" exclaimed Pete, "why we've even had sex with crocodiles."

"He means some of his women haven't been too tasty," explained Dave, you should have seen some of 'em mate. Made T Rex look like pussy cats."

"Thank god I have Isabel," said Lance, "at least the girl I know at night is the same one I wake up with in the morning."

"Yeah my wife does that and disappoints me everyday," said Pete.

"What about you Russ?" asked Jeanette, "you got a good looking wife?"

"No," replied Russ, "never have time in my job to see anyone outside of work. If I fancy a tasty Sheila at the office by the time I get back from a trip some one else has muscled in. Given up hope girl. If it happens then it happens."

"How long you got now? Why not take me to a disco? Take an all American girl out before you go," Jeanette said coquettishly, "I'm no Mona Lisa but I'm no alligator either."

Russ jumped to his feet. "You're on," he said, "come on let's go. See ya fellas. Thanks lovely lady, you've just made my trip."

And they went leaving behind an amazed group.

"That's it, can't see him making the plane tomorrow," said Pete.

"He'd better," said Mom.

"Come off it Mom, Jeanette's a big girl. She can lead her own life," argued Lance, "let her have a bit of fun."

"A bit of fun is one thing," said Mom, nodding her head emphatically, "but a jump into bed with an unknown guy is quite another thing."

"No lady," smiled Dave, "Russ ain't unknown, we've known him for years."

Mom looked at him in disbelief but to everyone's relief she didn't say anything.

Jeanette didn't arrive home that night, nor the next day.

Instead a text message said, "we're fine. Gone to Orlando. lol. J."

"Oh Jesus," cried Lance, "that means Russ has gone AWOL. If he's missed his flight he could lose his job. Another illegal. Don't say I'm going to have to get a green card for him!"

Jeanette turned up two days later. Glowing.

Nobody said a word to her at first. They were waiting for her.

Everyone was buzzing.

Jeanette was singing.

In the end it was Brad who cracked, "for crissakes Jeanette tell us what happened."

Jeanette looked at him, put her nose in the air, and said, "are you a pervert or somethin'? How much detail do you want to know?"

"Whatever you can tell us sweetheart," said Brad with a wide expectant grin all over his face.

"Well I tell you this. Those Aussies are a bit rough and ready and he was rough and oh boy was I ready. He was so upfront. We went back to his hotel for a late drink at the bar and he says right out, 'well are we going to fuck tonight then? Do you want to?' I was a bit dumbfounded but managed to say yes."

"He then said, 'great 'cos I do too.' And we did. All night. In the morning we flew to Orlando."

"What about his flight and his work?" asked Lance.

"No problem. He changed to a flight out from Orlando. It's a weekend. He doesn't have to be back at work until Monday," smiled Jeanette.

"So what now?" asked Isabel, "I had a one night stand here you know when I was on holiday and look what happened to me. Look what happened to Wunderwear Woman. I came back for more. What about you?"

"Well, now you ask perhaps I can tell," Jeanette said shyly, "he bought me a return ticket to Sydney where he'll meet me and take me to a place called Brisbane." (she pronounced it Brisbayne). He said the weather there is as good as Miami's so I'll feel comfortable. Not that we'll come out of the air conditioning much," she giggled.

Mom's expression was thunderous.

The rest were surprised but amused and pleased for her.

"The local American boys not good enough for you?" Mom asked crossly "what about a nice Italian boy like your father?"

"I divorced a nice Italian boy like Pa if you remember," replied Jeanette, "swore to love and care for me forever as long as I didn't mind him loving and caring for a whole lot of others along the way. No thanks I'll take my chance Down Under."

"Down Under him or the world," asked Brad cheerily.

"Both, smartass," replied Jeanette, "I'll be down under him Down Under!"

"When do you go," asked Isabel.

"Three weeks time," said Jeanette, "got a bit of time to prepare. Is it okay with you Lance? About the business I mean?"

"Nice of you to ask," Lance said grumpily, "but if you've gotta go then you've gotta go as they say."

"I've gotta go, as I say," Jeanette replied happily, "thanks bro', appreciate it."

"Ah Jesus!" exclaimed Brad, "I don't know how to say this family but I'm going to New York. Is it bad timing?"

Lance spluttered, "when for crissakes? When did this come up? Where did this come from?"

"From the big Apple itself," smirked Brad, "got an sms this morning. I go tomorrow. Short notice I know but you did say if you've gotta go then you've gotta go didn't you?"

"I meant Jeanette you moron," Lance shouted, "I wasn't talking to you! Anyway answer my question for god's sake."

"I thought I just did," said Brad, "I have a date. Samantha is there on business and messaged me that she felt like a bit of rough. In fact she wanted a lot of rough. She asked what I thought about that. Could I oblige."

"And you didn't think about it you just said yes? Right?" Lance almost snarled, "thinking through your dick again."

"Yeah," grinned Brad, flexing his muscles and wriggling his pelvis, "good ennit? Powerful stuff."

"Just a minute, did you say Samantha? You mean my arch enemy English Samantha?" queried Isabel, "she's called you?"

"Yes, why?" Brad asked defensively, "what's so surprising about that?"

"Well she lied, dumped and fooled you when she was here," said Isabel, "she used you, that's why?"

"So what? She'll do it again," Brad cried happily, "but she's a great fuck and she's paying. I've hit pay dirt people! Prepaid Pussy, pizza and pumpkin pie. Yeah man!"

Lance had to laugh in spite of himself. "When will you be back?" he asked.

"Don't know bro' do I? I know we're busy but we have guys who can stand in for me for a while. You can take it out of my pay, okay," said Brad magnanimously.

"Don't worry, I was going to," said Lance.

Isabel looked dumbstruck.

"You all right dear?" asked Mom solicitously, "you've gone off colour."

"I am off colour," replied Isabel, "but Samantha's gone off her rocker. Well, well, well, next thing we know we'll be hearing wedding bells."

"Hearing a load of bells will be a big relief after hearing a load of balls," chuckled Lance, "my brother's pulled a posh tart. What about that?"

"I've pulled as well," interrupted Jeanette, looking a bit miffed.

"Of course you have darling," Mom said consolingly, "both of you have pulled posh sure enough. Who'd have thought it?"

Brad came down for his cab to the airport with a small bag. A very small bag.

"Where's your bag?" asked Lance.

"Here," replied Brad.

"No, I mean your real bag," said Lance.

"This is it," answered Brad impatiently.

"What's in it?" asked Lance.

"My boxers, a toothbrush and honey flavoured condoms?" Brad responded, "what's it to you anyway? What's with the inquisition?"

"Well you're going to New York without a change of clothes. What is it? A one day turn round, a one night stand?"

"She said 'come as you are' so I am," said Brad.

"Where were you when you got the message," asked Lance.

"In the bathroom taking a leak," Brad smirked.

"So go on then, either get on the plane with your dick in your hand or go and pack properly," Lance responded.

Brad did with a sullen look on his face.

Three weeks later they gave a tearful farewell to Jeanette on her way for a few weeks holiday in Australia but Brad was missing.

Brad was still in New York.

They had messages galore but no Brad.

Samantha had gone back to the UK but Brad had not gone back to Miami.

He was being passed around her smart executive colleagues who regarded him as a figure of fun and a bit of ridicule. Brad realised it but didn't care.

"Have you no shame?" asked Isabel.

"Nope," replied Brad during one conversation," I know they regard me as the village idiot but I get free board and lodging, free five star food, designer clothes, group fucks every night and presents galore. They pay. Who's the idiot?"

"Not sure," Isabel chortled, "but don't tell Mom. She'd soon answer your question but it's Lance I'd worry about if I was you. He's not amused. If I were you I'd get home quick because he says if he has to come up there after you he will make you into a eunuch with a squeaky voice in ten seconds flat. You'll be neutered in New York."

Brad came home.

In order to escape Lance and his anger Mom sent him to Father O'Halloran to confess.

It took three sessions as the Reverend Father demanded exact details in order to obtain God's forgiveness.

Brad said that he seemed quite excited and breathless and often asked to go over it again.

Brad said he didn't mind as it got him excited as well.

After a few days Father O'Halloran phoned up and asked Brad if he was sure he had remembered everything in his confession because if he hadn't he could always come back.

When Lance heard he exploded, "what does he think this is a frigging soap opera series or something? If he wants to get off on your stories tell him to go to the Big Apple and collect some of his own."

"I did," Brad grinned, "and he asked me names and addresses!"

"Get outta here," laughed Lance, "get back to work and earn your living for a change. Always remember that men pay more for a pretty pussy than women do for a prominent prick."

"Not anymore bro," chuckled Brad, "not any more. God bless the feminists."

A week later Father O'Halloran telephoned Mom complaining that he hadn't seen Brad at confession for a while.

"Brad!? You mean our Brad?" asked Mom, "at confession. Jesus, Joseph and Mary, would the saints believe it? What on earth did he have to confess?"

"Rather a lot, Maria, I wouldn't like the boy to be burdened," said O'Halloran piously, "better to get it of his chest."

"Tell me what exactly and I'll get it off his chest all right," exclaimed Mom ferociously.

"Now, now Maria you know we can't break the sanctity of the confessional can we," replied The Father.

"No but I can break his neck," cried Mom, "I'll give him New York. It won't be the Big Apple for him, it will be crushed nuts. I'll beat it out of him."

"Right Maria, I understand," said The Reverend, "however you will be sure to tell me everything in your confession won't you!?"

Neo-what!!??

Brad came into the office looking stern.

"I think you better come down to the pier-head and take a look at this," he said to Lance and Isabel.

"What's up?" asked Lance.

"You'll see," answered Brad.

They followed him with questioning looks.

When they got down to the jetty and waterfront Brad pointed out two guys handing out leaflets.

"So?" said Lance, "what's wrong?"

"It's not good bro, not good what they're saying. I don't like it," Brad replied.

"Whatever! It's a free country you know. You don't have to agree. They're entitled to have their opinions whether you like it or not," said Lance.

"Not these opinions," said Brad, "millions died because of talk like this."

"Let's take a closer look then," said Isabel, and went up to the bigger of the two men and asked for a leaflet.

"Here you are sister," shouted the guy, "help to get this glorious country of ours, this America back, on track. Help us to reclaim our country. The jews, the faggots, the blacks, the ragheads and the commies are running things here, are controlling the money, the politics and our

89

lives. They're destroying the all American family and our basic society. It is not the enemy without we should be fighting but the enemy within. Join us in our quiet, silent majority revolution." His voice rose to a resonating crescendo.

"Not so bloody quiet then is it," said Wunderwear Woman, suddenly transformed from Isabel, "you shouting your head off spouting rubbish. Who's controlling what for crissakes?"

The small guy seemed taken back but quickly recovered. The big guy appeared about to burst.

"Open your eyes. Just look no further than the White House. We have a black illegal moslem immigrant sitting in the President's chair," he blurted out passionately.

"A true American through and through actually. Transparently, fairly and freely elected by the majority of the population. Why not open your eyes and use your brain instead of your mouth," exclaimed Wunderwear, "he's an intellectual giant compared to ignorant morons like you."

"I can see the jews have brainwashed you," said little man, "that's why Israel cannot exist. It only exists because of the jews in America."

"Thank god for America then. But it's not only us that stands in the way of the Arabs practicing out of control ethnic cleansing. Most other civilised countries feel the same. It doesn't mean we think Israel and the Israelis are perfect but it does mean we believe they have a perfect right to exist in peace and security. Not easy to behave that well when you have millions screaming for you to be annihilated, is it?"

"Ethnic cleansing? If you mean the holocaust then I tell you it never happened. It was a propaganda invention by the Zionists to steal land from the Palestinians," little big man said fervently.

The holocaust? I tell you it never happened.

"Yes you're right of course," said Wunderwear, "Heinrich Himmler was not a bastard mass murderer. He was a genius of a magician, more brilliant than David Copperfield who only made a train disappear before a large audience. Himmler made six million jews disappear before the whole world. What a trick that was. Even fooled such an unprejudiced fair man like you."

"Where would the world be without fair minded neo nazis like you two to put us right? We need you to give us a reality check from time to time to show us that evil still exists and that bird brained people often have the biggest mouths.

Thank you for giving Americans a wake up call. Wake up to the fact that virtually every American was an immigrant and no matter what race, colour or religion they are they came to this land to be free."

No holocaust? No, because Himmler was not a mass murderer but a genius of a magician. He made six million jews just disappear before the whole world??!!

"Thank you gentlemen, can I have the rest of your leaflets? I want to give them to my friends to use as toilet paper. That's about all they're worth."

Wunderwear Woman turned her back on them and walked away.

The Sporting Life

"Hey Isabel," cried Brad one morning, "have you seen this in today's paper? One of your soccer players has just been given an unbelievable contract. His salary is out of this world. How do I get in?"

"You don't, you're too old," smiled Isabel, "anyway what's soccer? Where did that come from?"

"Soccer, you know? Well. Soccer, you know?" said a bewildered Brad.

"No! Me, and the rest of the world don't know," said Isabel, determined to be unhelpful, "if you are talking about the beautiful game that the whole planet plays and adores and if you call it by it's proper name of football then I might just begin to understand."

"Ah," said Brad somewhat triumphantly, "we play football, you play soccer."

"No you play a game that has a five minute meeting bending down, then stand up, chuck the ball while all the players have a fight, fall down with the ball, bend down for another meeting and start over until you cross one of the many lines. Only then do you kick the ball once. It's not even a ball shape by the way," Isabel said without taking a breath, "what's more the players do it in fancy dress and run as though they are going uphill with bare feet on hot coals. No one in their right minds could call it football. It's not even close."

Brad was silent, then, "we do."

"You do what?" asked Isabel.

"We call it Football," replied Brad.

"But it isn't is it?" said Isabel, "not remotely. Look we have a similar game for real tough guys who wear sports clothes and wouldn't be seen dead in fancy dress. We call it rugby football. It's also worldwide. In Australia and Ireland they have similar deviants and they call it Aussie rules or whatever. You should always call it American Football. Anyway you do play proper football here and are good at it. So join the rest of the whole world and truly have a World Series instead of a marketing fake."

Fortunately Mom came in just in time to prevent violence. "What's this about football? Change the subject. A load of grown men playing kid's games and wanting payment. Boring, boring, boring. I'm off to meet Mai, you know my banking friend. Want to come? She's got some people with her who want to meet Wunderwear. Can't think why."

Brad and Isabel agreed to go more with a sense of relief than anything else.

They naturally thought that they were going to a bar or coffee shop but instead, much to their surprise, they went to a leading bank, were ushered past security and were shown into a large meeting room.

They lapsed into an overawed silence.

They felt insignificant grouped together in a bit of a huddle at one end of a huge table.

They jumped as the door opened then relaxed when they saw it was a refreshment trolley leading the way before a roly poly woman in a track suit that would have made Wunderwear Woman in her early days look slim.

She parked the trolley, beaming a smile from between rosy faced smooth cheeks.

"Help yourself to whatever you want," she said and waddled out with everything swinging like the pendulum in a huge clock.

Nobody moved.

"Do we want something?" Isabel whispered and then wondered why. She giggled, "do you think we're being watched or recorded? I mean you never know do you?"

"Be somewhat disappointed if so," said Mom, "we've not said anything yet."

"Let's fool 'em then and not say anything brilliant," offered Brad in a positive voice.

"Won't be difficult in your case will it?" Isabel said sharply, still smarting a bit over the soccer football row.

Mom intervened with, "I think it's better that we say nothing at all until we see why we're here and what we are to do about it. Then we'll see if we can rise to the occasion."

Brad and Isabel subsided and shut up.

When the door opened Isabel had a surprise. The first person in was an economics professor from the UK followed by Mai and three or four others.

The professor she had seen somewhere before and of course they all knew Mai.

They smiled, introduced themselves, and sat down. Fortunately close to the family.

"Thank goodness for that," said Mom, "if you had sat down at the other end of the table we would have been shouting at each other."

"From what I heard previously from Wunderwear Woman I thought that would be normal," smiled the professor.

"Ah but I'm Isabel now," she said silkily, "I only morph into Wunderwear when provoked."

"We'll have to see what we can do about that then, won't we?" Mai said firmly, "we haven't come here to sing nursery rhymes."

"Why have we come then?" asked Mom.

The prof' spoke first, "quite some time ago I overheard a conversation in a wine bar in London where this young lady was trying to put over a few serious points to friends who were not serious at all." He pointed at Isabel. "She was on about caring and sharing and not blindly following three hundred year old economic doctrines.

It just stuck in my mind and then when Mai here told me about a meeting with a very forceful family with a very forceful Brit I put two and two together and came up with Wunderwear Woman. So here we are."

So here he was from the UK, a typical Economics Professor.

"Oh god, that damned wine bar and my friends have come back to haunt me," said Isabel, "Mai are you getting your revenge? Dumping us into a Davos World Business Forum situation are you?"

To Isabel's surprise the group burst out laughing.

"Spot on girl, spot on?" Mai cried out delightedly, "we are all some of the 'backroom boys' at those events. Without us and the scriptwriters the big wigs wouldn't know what to say. What do you think?"

"I think that there is so much bullshit spouted that it would fertilise the American wheat fields for a hundred years. The UN, the EU, The World this and that Forums, are all jobs for ineffectual old boys who utter platitudes, pat each other on the back and spout obvious rubbish with the utmost conviction," exclaimed Wunderwear who had left Isabel behind her in seconds, "they are put there as useless figureheads in the hope that they will never actually do anything at all. But they talk nice!"

"But don't they represent a great ideal?" asked one lean and hungry gent.

"Yes, but the ideal gets lost in a mass of unnecessary detail. The real issues are crowded out by dissent and irrelevancies. By the time any decision is made it is usually too little and too late. In the meantime things go on just as before which frankly I think was the real objective," said Wunderwear.

"Don't you think that what you say could be viewed as offensive?" asked one woman who reminded Wunderwear of a school headmistress.

"Oh for crissakes come off your high horse. It's so bad now that everyone is queueing up to be offended. In fact it's an offence to be inoffensive. Cut through all the hypocritical pseudo polite crap and get a dose of down to earth reality," Wunderwear shrieked.

"Okay," said the professor," so in your reality what has gone so wrong with the system? Why doesn't it apply to today?"

"Because it was evolved either by accident or design at the start of the industrial revolution. What was needed then is not needed now. It broke down cottage and traditional industries. It needed larger markets and the additional transfer of capital away from rural aristocracies into skilled entrepreneurs who possessed the ability to evolve large scale projects. It needed new methods of power and transportation in a world that was underpopulated because of disease. Where communication was slow and expectancy was low," replied Wunderwear, "where wealth was expected to make things and put people into work."

"So?" said the headmistress type.

"So now wealth goes to create wealth and fuck the product and work. The people who make things are shoved on the shelf while those who print banknotes live in style. Labour is made a scapegoat by those who never got off their arses to do something useful. We are so fixated on minorities that the majority get overlooked and become increasingly resentful. And you just go on churning out the same old rubbish that has no solution to the everyday problems of more than six billion people with much higher expectations and means of communication."

"All right," said Mai," other than population increases, unemployment and a system that has no answers, what is there?"

"Stop the propaganda war for a start," stated Wunderwear, "you have three opposing parties that should work together but don't. America is the most guilty. You have labour, government and business. A not so

golden triangle! If you listen to the Republicans and other Conservatives you would think the three of them are deadly enemies undermining each other and under the present system you would be right. It pits them against each other when in fact they are interdependent. Most of the cock ups in the system are due to this. The faceless suits want less government and think labour is the root of all evil. Blue and White collar workers depend on and contribute to business success and regard every action by management with suspicion. Governments depend on the electorate the majority of whom work hard for a living but instead favour capital. Governments get blamed for the failures of business and business blames regulations, workforce and government while the workforce blames everyone regardless. Then while they're fighting each other everything is left to the so called free market to miraculously solve all the problems. You call that a system? I call it a sick joke."

"Wow," said the prof', "you were right Mai. What an entertaining afternoon. Gives us something to think about eh?"

"Hey, you patronising old bastard," exclaimed Wunderwear Women, "I thought I was making it clear that I don't want thinking I want action. Bang heads, get people together. Work out a balance between workforce, business and government. All have to be more responsible to each other for their actions. They don't operate in a vacuum. Go back to the drawing board. Don't wallpaper over the cracks. Business has to work with and not against labour and government. It has to accept sensible short and long term controls. The same applies in reverse. Business cannot be choked off but blatant uncontrolled capitalism should be outlawed. It favours monopolies and is the enemy of production, innovation, progress and the free market. The justified acquisition of capital for future advances is not. Stock markets and banks have to be reviewed in a more radical way. World economies cannot be held to ransom by reckless gamblers posing as investors using other people's money.

Extreme wealth has to make way for comfortable wealth. The inventors and discoverers of the world's innovations did so mainly out of great curiosity, rarely for a platinum credit card that they didn't invent. They did it for a multitude of reasons combining co-operation and competition. It was America who focussed almost entirely on bigger and bigger profits. Bad deal man, bad deal. Wake up before it is too late. Before greed destroys the world we live in!" she finished dramatically.

"You do realise we are aware of these things don't you? I have to agree that you have not only asked but also answered some questions," the lean man said thoughtfully. He had been nervously fidgeting the whole time.

"Yeah okay, aware, but so what if there's no action. "said Wunderwear, "now it's not enough to simply answer the questions you have to question the answers and act! The reason you keep getting the wrong answers is that you keep asking the wrong questions. You are trying to shore up an antiquated system as though it was a religion. You think it's a science when real scientists laugh at you. If they had kept to outdated beliefs, systems and doctrines like you lot then you wouldn't have your corporate jets. You would still be trying to take off from the top of a mountain frantically flapping feathered wings and crashing. It needed a fundamental change in understanding and approach to be able to do all the things that we accept today. But you insist on still sticking to an outdated system that was not designed to deal with modern times. Get off your high horse, wake up and grow up for God and humanities sake."

"I certainly don't feel the urge to do that today," smiled the prof', "but I have recorded all of this and will run through it again. I hope you don't mind?"

"Of course I bloody well mind," thundered Wunderwear, "it's a bit late to ask me now, ennit? If you had any guts and decency you should have asked me at the beginning. I'm not some celebrity and I don't want to be famous for being famous. So delete it will you?"

"Oh dear, I'm sorry if you're offended," said the prof' hastily, "here, look, I'm deleting it now. Hows that? I do apologise."

With that they all stood up, made their goodbyes and left. A secretary came in and affably escorted the family to the front door.

"Isabel, my darling," said Mom, "you do realise that some of the others made recordings as well don't you?"

"Of course Mom," Isabel chuckled, "I was just being difficult. After all I have a reputation to keep up. Anyway I only gave them an outline I kept the details close to my ample bosom."

They all grinned and decided to wet their whistles at the nearest bar.

Wedding Bells

Jeanette was home. Radiant.

"Mom it was marvellous. I felt like a queen. Parties every night to welcome me and day trips later to show me around," she cooed.

"So your boyfriend neglected you then?" Brad smirked hopefully, "thought he would."

"What! No way," Jeanette shouted happily, "Russ was wonderful. Took me with him a few times. He flies the company plane. A funny little thing, only room for two but it has a coupla' engines in case one fails. If we crashed we'd be miles from anywhere. Now that's exciting. Makes Disneyland seem like kid's stuff."

"Disneyland *is* kid's stuff," grinned Lance, "so what happens next? Do we look at the photos, gasp in wonder and then get back to work?"

"Nope," said Jeanette breathlessly, "wait for it, wait for it. Can you guess what's coming next?"

"Yeah," said Brad laconically, "you're pregnant."

He just managed to dodge two punches coming his way.

"Not yet," Jeanette said glowing, "but I wanna be. You see Russ asked me to marry him and I said yes, oh yes please."

She absolutely shouted the last few words.

Isabel and Lance looked across at Mom who had gone quiet.

"It's a long way," she said finally, "I suppose there's no chance of him coming here is there?"

Jeanette was too wound up to notice the sadness.

"Come here!?" she exclaimed, "what would he do here? These are real men. Quiet tough men. Not loud mouthed show off pretend macho guys like some I know."

"If you mean me then I take that as a compliment," Brad smiled, "I just object to the pretend bit sister. I believe in me. I mean they're not all Crocodile Dundee down there either are they? I mean somebody has to work for a living."

"Brad, you're my brother and you are great but I'm in love and I can't waste time. I've got a lot to do," she said and then ran off to her room.

"You all right Mom?" asked Isabel, "are you okay with this?"

"It doesn't matter if I am or not," said Mom matter of factly, "she's a big girl, been married before and wants to settle down properly and have a family. It's just that I won't see them very often. But if she's really set on it and happy then I'm all for it."

"We don't know much about him or his mates really but they seemed decent enough fellas so let's go along with it and give her our support."

"It hasn't happened yet either," said Brad, "many a slip you know?"

"I'll slip you one in a minute," laughed Jeanette who had just come back, "it will happen believe you me. He's coming here with his family to meet you all. He thinks we should get married here, stay a while and then move out to Oz."

"Well that's thoughtful," said Mom obviously relaxing, "I should like that. Then afterwards we can all come and visit you."

"YEAH," shouted Isabel, "Wunderwear Woman Down Under. Bring it on."

Yeah, Wunderwear Woman Down Under, bring it on.

THE END

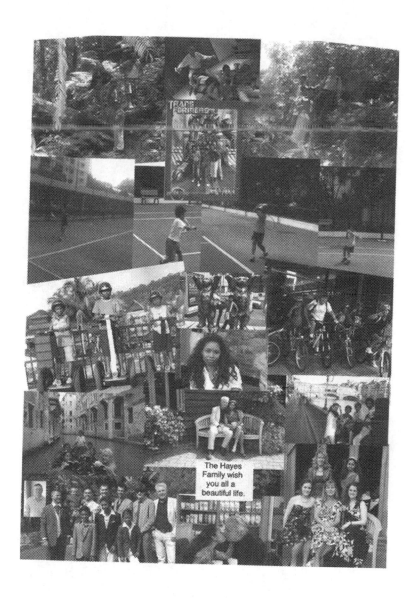